The Lost Mill Village
of Middlesex Fells

The Lost Mill Village
of Middlesex Fells

DOUGLAS L. HEATH AND ALISON C. SIMCOX

THE
History
PRESS

Published by The History Press
Charleston, SC
www.historypress.net

First published 2017

Manufactured in the United States

ISBN 9781467136679

Library of Congress Control Number: 2017934948

Notice: The information in this book is true and complete to the best of our knowledge. It is offered without guarantee on the part of the authors or The History Press. The authors and The History Press disclaim all liability in connection with the use of this book.

To our mothers, Dorothy Thayer Heath and Margaret E. Simcox,
whose lives inspire us and whose love sustains us.

Contents

Acknowledgements

First, we acknowledge the contributions of women who helped their husbands and sons succeed in their mill businesses and endured the hardships of domestic life in past centuries. We recognize the children who worked and suffered in mills and factories before the passage of child labor laws. We also acknowledge the African Americans who worked for the mill families, many as slaves, and were denied the dignity of full citizenship. All of these people are part of our shared history.

We thank many people for helping make this book possible. First, Ryan Hayward of the Preservation Collaborative generously shared his extensive knowledge of Haywardville as well as photographs and historical documents. We thank Gary Walter of the Colchester Historical Society for granting us access to the society's collection of Hayward family photographs. Susan Lisk of the Porter-Phelps-Huntington Museum in Hadley, Massachusetts, allowed us to include portraits of William and Mary Barrett in our book. Donald Delay and Priscilla Scroggins, great-grandchildren of Susan (Dean) Richardson, kindly provided images of her brass school bell and gold pocket watch.

The following groups lent us materials from their collections: Stoneham, Melrose and Malden Public Libraries; Amherst College Library; Baker Library at Harvard University; Medford Historical Society & Museum; Stoneham Historical Society; New England Historical Genealogical Society; American Antiquarian Society; Massachusetts Archives; and the South Middlesex County Registry of Deeds.

ACKNOWLEDGEMENTS

As always, we thank our wonderful sons, Ian and Alec, who remind us that history only stays alive if passed on to younger generations. Last, but not least, special thanks to Amanda Irle and Ryan Finn, our editors at The History Press, who were supportive throughout.

Introduction

At the end of the Wisconsin glacial period, about fourteen thousand years ago, the landscape north of present-day Boston was sculpted by glaciers, pocked with kettle ponds and littered with boulders. Gushing streams, carrying meltwater from wasting glaciers to the north, rushed downhill and discharged into the sea. By nine thousand years ago, hardwood trees—such as beech, oak and maple—had begun to appear, and wetlands provided rich habitats for plants, birds, deer and other animals. By this time, the first people, known as Paleo-Indians, had moved into the area. They hunted caribou and other tundra animals using spears with fluted points, which have been found on hilltops, the sides of valleys and the shores of glacial lakes throughout New England.

Sites dating back 9,500 years exist on the Arlington Plain and lower Charles River, along the shores of the Mystic Lakes and along the Saugus River. Native people caught fish from the Mystic River and Alewife Brook and shellfish from the nearby coast and traveled inland to camp during the winter. By about three thousand years ago, their descendants had developed additional tools for hunting, including fish weirs, and were making pottery and growing squash and gourds. They had also begun settling in campsites, with trading becoming more important.

At the time of European contact in the seventeenth century, native people in northeastern Massachusetts were the Massachusets (or the Pawtuckets, according to some scholars). Their chief sachem was Nanepashemet, and his domain stretched from the Charles River north to present-day Salem,

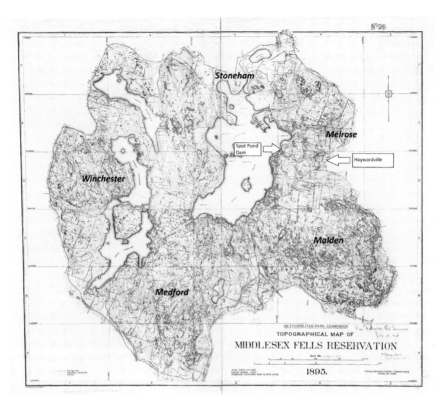

French, Bryant & Taylor, topographers of Brookline, Massachusetts, published this map of Middlesex Fells Reservation in 1895 for the Metropolitan Park Commission. The reservation lies five miles north of Boston in Stoneham, Medford, Melrose, Malden and Winchester. *Boston Public Library.*

Lynn and Marblehead and extended westerly to Concord. In 1619, Nanepashemet was killed by Mi'kmaq raiders from the north (also called Tarrantines), and his wife, Squaw Sachem, took over his domain. One of the areas where the Massachusets lived, an area that had been inhabited for thousands of years, was on the northern and eastern shores of a glacial kettle pond, now called Spot Pond. They built wigwams with saplings arranged in a circle and bent to form an arch at the top, which they covered with bullrush leaves. Daily life focused on growing crops such as squash, maize and beans; hunting and fishing; and making tools. But contact with Europeans altered their culture profoundly. Diseases decimated the native population. By the mid-seventeenth century, most remaining native people had left the coastal lowlands under pressure from the growing British colony and moved to nearby upland areas.

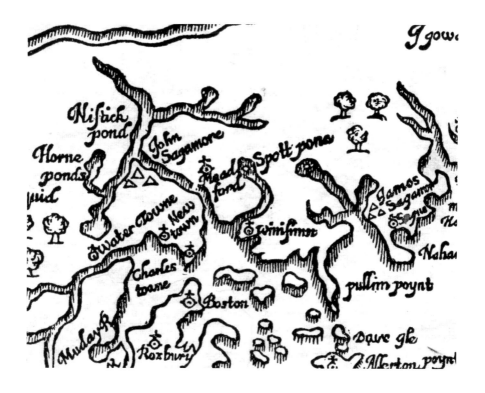

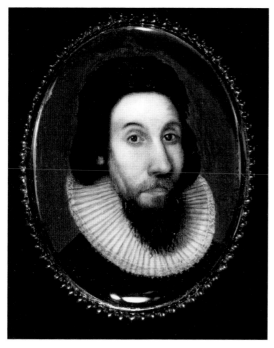

Above: Detail of William Wood's map of New England, published in London in 1634 in the *New England Prospect*. This is the first map made showing Spot Pond and Spot Pond Brook (flowing southward).*Boston Public Library*.

Left: Circa 1630 portrait of John Winthrop made by an unknown artist, probably in England. While governor of the Massachusetts Bay Colony, Winthrop explored the Spot Pond area in 1632. He married Martha (Rainborowe), the widow of Thomas Coytmore, who built the first mill on Spot Pond Brook. *American Antiquarian Society*.

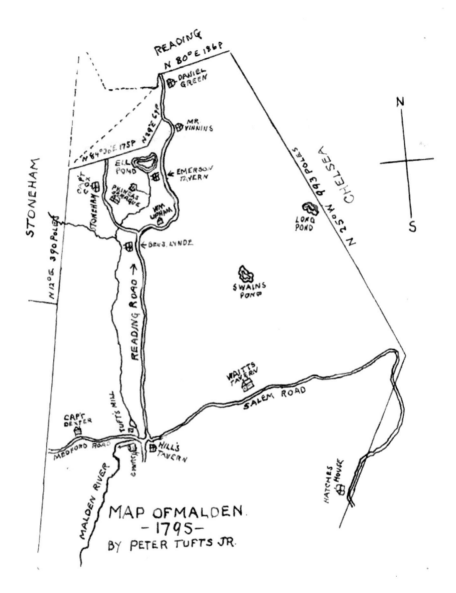

Above: Peter Tufts Jr. drew this map of Malden in 1795. It shows Tufts's mill (formerly Coytmore's mill), Hill's Tavern and Spot Pond Brook flowing eastward from Stoneham and southward parallel to Reading Road. *Malden Public Library*.

Opposite, top: This enlargement of G.M. Hopkins's 1874 map of Stoneham shows property boundaries and mills along Spot Pond Brook in Stoneham. *Stoneham Public Library*.

Opposite, bottom: Parker W. Perry's 1934 map showing Haywardville in 1860. *Stoneham Public Library*.

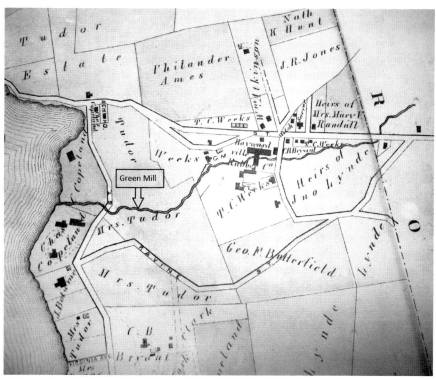

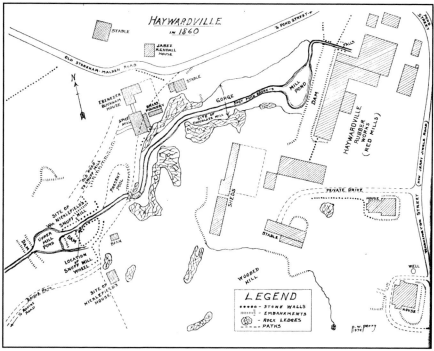

No one knows by what name the native people called Spot Pond. In colonial times, the pond was located in the northern part of the Charlestown territory known as "Charlestown End." In February 1632, John Winthrop, governor of the Massachusetts Bay Colony, explored this remote area and wrote in his diary that he, Increase Nowell, John Eliot and others "came to a very great pond…and the pond had divers small rocks standing up here and there in it, which they thereupon called Spot Pond." Two years later, Spot Pond was included on a map in William Wood's book *New England's Prospect*—the first published map of the colony.

A brook, not mentioned by Winthrop but included on Wood's map, flowed out of the east side of Spot Pond and down a steep ravine that had been formed by a rushing glacial stream over thousands of years. The stream, which came to be known as Spot Pond Brook, flows a length of three miles to "Mistick Side" (now Malden) before joining a river (Malden River), which, in turn, joins the Mystic River that flows into Boston Harbor and the sea. The brook was well situated to become a focus of early industrial development.

At the time of Winthrop's visit, colonial towns were already forming north of Charlestown. Medford, a center of brickmaking and shipbuilding, was established as early as 1630. Mistick Side was settled a few years later and incorporated as the town of Malden in 1649. The area northwest of Mistick Side was known as Charlestown End. This was to become the town of Stoneham and a center for shoemaking. Two centuries later, the northern part of Malden separated to become the cities of Melrose and Everett. But in Winthrop's time, these emerging towns were sparsely populated with a few farms and rough dirt roads. Among the many things that colonists needed were mills for grinding corn for themselves and grist for their animals.

Chapter 1

Early Days in Charlestown, 1628–1640

The story of the mills on Spot Pond Brook began in the early Puritan town of Charlestown. This settlement was located on a neck of land bounded by a natural harbor and two rivers, which colonists named the Mystic and Charles Rivers. In 1628, Charlestown was a scattering of dwellings built by settlers who had migrated south along the coast from nearby Salem. The settlers called the new village "Charlestown" because of its location at the mouth of the Charles River, which had been named in 1614 for the future King Charles I. In his 1937 book, *Stoneham: The Friendly Town*, Lemuel Standish described life in seventeenth-century Charlestown:

> *In those days the streams were dammed by beavers, the sheep were a prey to wolves, the bears roved through the woods, and now and then the hunter brought down a deer. During those years our ancestors lived a life the habits of which were simple. It was a contest with a rigorous climate and a barren soil for the bare necessities of existence, but it produced a strong and rugged character. They may have been rough and uncouth and uneducated, but they possessed the best traits of English yeomanry.*
>
> *…there were no carriages, no crockery, no glassware, or hardly any furniture except bedsteads, chairs and boxes. The only fire was that of the fire-place. Carpets and rugs had not yet come into use. No curtains were required to shield the inmates from the curiosity of the passersby. There were no watches or clocks to indicate the time. No metals more precious than iron, brass or pewter and tin filled their cupboards or*

*covered their tables. Potatoes had not come into general use. The simple
articles of food were Indian corn, wheat, rye, barley, and pork, with
mutton and beef at intervals, and doubtless veal and lamb now and
then. Coffee and tea were luxuries of the future and probably sugar was
little in use. Flour as we have was unknown. Garden vegetables were
cultivated to no great extent. Milk and cheese they possessed at an early
day in abundance. Wild game was plenty. The cloth was for the most
part home-spun. To a very large degree their purchases were exchanges,
grain taking the place of money as a medium of exchange. It is safe
to assume that during the first years of the settlement, wagons were
used....Almost every man was a farmer.*

The men and women who settled in Charlestown and elsewhere in the American colonies brought with them customs and tastes of generations of English life. Their standards of living, choice of trades and methods of barter and commerce were modeled on English life and customs. Ships crossed the Atlantic at frequent intervals, their holds filled with necessities and luxuries—food, fabrics, tools—based on English standards from shops in London, Plymouth and Bristol. These goods could not easily be produced in the American settlements.

According to Cressy's *Coming Over*, Reverend Francis Higginson, the first minister at Salem, advised those embarking on a voyage to the colonies to "be sure to furnish yourselves with things fitting to be had before you come: as meale for bread, malt for drinke, woolen and linnen cloath, and leather for shoes, and all manner of carpenters tools, and a great deale of iron and steele to make nails, and locks for houses, and furniture for ploughs and carts, and glasse for windows, and many other things."

Higginson had come over in the *Talbot* with a crew of thirty men and more than one hundred passengers. His ship carried "twenty-two hogsheads of salted beef, twelve thousand of bread [biscuits], forty bushels of peas, twenty barrels of oatmeal, 450 pounds of salt fish, ten firkins [small wooden casks] of butter and twelve-hundred pounds of cheese. To wash down this food, they took on board six tons of water, forty-five tons of beer, twenty gallons of brandy, twenty gallons of Spanish wine (Malaga and Canary), two tierces [eighty-four gallons] of beer vinegar and twenty gallons of olive oil." One of the few items that colonists didn't need to bring was sugar. Colonial vessels traded goods for sugar from the West Indies.

To obtain goods from England, the colonists needed merchandise to trade, and so their vessels went back loaded with lumber, salted fish, beaver

and other animal pelts, raw wool and foodstuffs. The colonists also built ships for the English market using their abundant supply of trees.

The vessels that brought the great migration to New England between 1630 and 1640 were of small tonnage, and passenger accommodations were cramped. As well as men, women and children, the ships carried livestock housed in pens and shelters built aboard ship, leaving little room for people to move about the deck. Inevitably, many arrived in poor health, shaken by the sea passage. They then faced the severity of the New England climate, especially the biting cold of winter.

Upon arrival in the Massachusetts Bay, settlers needed shelter. Few had the means to build farmhouses, so they fashioned shelters using whatever means were available. Deacon Bartholomew Green, printer of the *Boston News-Letter*, wrote that when his father arrived at Boston in 1630, "for lack of housing he was wont to find shelter at night in an empty cask," and during the following winter, many poor people continued to live in tents. When Roger Clap arrived at Charlestown in 1630, he "found some Wigwams and one House." John Winthrop wrote in his journal that "the poorer sort of people (who lay long in tents) were much afflicted with scurvy and many died, especially at Boston and Charlestown." Winthrop also mentioned English wigwams.

In his *New-Englands Plantation*, printed in 1630, Reverend Higginson described wigwams that were built by native people as "verie little and homely, but made with small poles prick't into the ground and so bended and fastened at the tops and on the side, they are matted with boughes and covered with sedge and old mats." The English version of a wigwam was probably modified to include a stone or brick fireplace at one end, a wooden door at the entrance and rushes or straw on the floor, following the style of English cottages. There are other reports of early settlers digging cellars in the earth, spanned with wooden spars and covered with turf.

The earliest frame houses were covered with weather-boarding and, before long, with clapboards. The walls inside were sheathed up with boards, and the intervening space was filled with clay and chopped straw and, later, with crude bricks for warmth. Immigrants to Massachusetts Bay brought supplies of glass for windows, but in the poorer cottages and wigwams, they made do with oiled paper. Glass was usually diamond-shaped, set in lead cames (slender, grooved bars of lead). It wasn't until the end of the seventeenth century that houses most associated with colonial New England became common—that is, wooden two-story dwellings built around brick chimneys containing large fireplaces.

According to George Dow's account of everyday life in the American colonies, the new settlements needed men skilled in trades, "an ingenious Carpenter, a cunning Joyner, a handie Cooper, such a one as can make strong ware for the use of the countrie, and a good brickmaker, a Tyler, and a Smith, a Leather dresser, a Gardner, and a Taylor; one that hath good skill in the trade of fishing, is of special use, and so is a good Fowler." The need for tradesmen, especially blacksmiths, led some towns to offer grants of land and buildings as an enticement to settle in their communities.

The first mills for producing domestic goods were sawmills. The earliest of these were built on the Piscataqua River, a twelve-mile-long tidal river marking the boundary between the states of New Hampshire and Maine. But sawmills soon appeared wherever water power was available, replacing labor-intensive saw pits. Gristmills (also known as corn or flour mills) soon followed. These were mills where farmers brought their grain, which the miller ground into meal or flour in exchange for a percentage called the "miller's toll." Towns became dependent on the local mill, as bread was a staple part of people's diets.

Israel Stoughton is credited with building the first gristmill in the Massachusetts Bay Colony. Built in 1634, this mill was located on the lower falls of the Neponset River in Dorchester. Stoughton was a colorful character whose children included William Stoughton, the chief magistrate of the Salem witch trials.

Chapter 2

Coytmore's Corn Mill, 1640–1707

Just six years after Stoughton built his mill, the Charlestown selectmen decided that they wanted a gristmill of their own. They chose a site on Spot Pond Brook near its confluence with the Malden River, about four miles north of the center of Charlestown (see Tufts's mill on page 14). They identified Thomas Coytmore, a sea captain who owned more than 150 acres of local land, as a good candidate to build this mill. With an enticement of four acres of land on Spot Pond Brook and more than five hundred acres elsewhere in Charlestown (now in Woburn and Melrose), Coytmore agreed. According to Commonwealth of Massachusetts Superior Court records:

The 29 day of ye 11ᵗʰ month. Charlestown 1640 Mr. Tho. Coitmore Grant Land in Consideracon of building a Corne Mill at Misticke side. Mr. Tho. Coitmore was granted the end of his Lott, betwixt ye Mount Prospect & the River for his pper use in case hee goe on with building the Mill wch if hee doe not hee is then to leave 4 Acres to the use of such as shall have liberty to build ye Mill to be sett out by such as shall be appointed.

On the 27ᵗʰ of 6ᵗʰ month, 1641, "It was granted yt Thomas Coitmore should have one daies worke throughout the whole Towne, to help breadthen a Dam (at the 3 mile brook) to A convenient highway for horse & cart; and yt he shall have liberty to appoint what number hee shall thinke fitt for a day; proceeding accordg to the Liste of the Surveyors for the highway."

THOMAS COYTMORE

Thomas Coytmore, whose name was derived from the Welsh "Coetmor," was born in 1611 to Rowland and Katherine Coytmore in the coastal village of Prittlewell, east of London. Rowland Coytmore was one of the grantees of the Second Charter of Virginia in 1607 and a mariner with the East India Company, sailing to Indonesia and Java. Like his father, Thomas Coytmore followed the sea, eventually becoming a sea captain. In 1635, he married Martha Rainborowe of London, who was from an even more distinguished seafaring family. Her father, William Rainborowe, served as vice-admiral in the Royal Navy, advisor to King Charles I, ambassador to Morocco and member of Parliament. Her brothers, Thomas and William, were officers in the Royal Navy during the English Civil War.

Within a year of their marriage, Thomas and Martha Coytmore had a child, Katherine, who died soon after birth. The following year, 1636, they sailed with Coytmore's mother, Katherine, to Massachusetts. Coytmore's half sister Katherine Graves and her husband, Thomas Graves, who had become a rear admiral under Oliver Cromwell, arrived about the same time. Another half sister of Coytmore, Parnell Nowell, had already settled in Charlestown. She was married to Increase Nowell, one of the town's founders.

A few years after arriving, Thomas Coytmore was active in the Artillery Company of Boston and in the Church of Charlestown and was a deputy to the General Court of Charlestown. But, as will be seen, his days as sea captain were not over.

THE COYTMORE PRIVILEGE

Along with permission in 1640 to build a mill in Mistick Side, the town granted Coytmore the right to build a dam three miles upstream at Spot Pond, the source of water to Spot Pond Brook. With this dam, Coytmore had the right to control flow along the brook's entire three-mile length. In legal papers, this right is called the "Coytmore privilege" and may be the earliest instance of riparian water rights in the country. Having this privilege meant that anyone who built a mill along Spot Pond Brook would need permission from Coytmore, or subsequent owners of his mill property, to alter the flow of water from Spot Pond. And thus began more than 230 years

of disputes over water rights, ending in 1873 after the towns of Malden, Medford and Melrose began using Spot Pond as a water supply and steam power had largely replaced water power.

Coytmore's mill was located at the downstream end of Spot Pond Brook in what is now downtown Malden. Coytmore built an earthen dam to create a millpond to provide an adequate head of water to power his waterwheel and provide flow to his mill for short periods during dry spells. However, the main flow into the brook was controlled at Coytmore's much larger dam three miles upstream at Spot Pond. This dam changed little from the mid-seventeenth through eighteenth centuries. As Levi Gould described it in Massachusetts Superior Court in 1904:

> *The dam on the east side was built of stone, rough stone, and was filled in on the west side with smaller stone, riprapped, and with coarse gravel. On the top of the dam…somewhere in the vicinity of 15 feet wide…there was…bushes and trees of greater or less size. There was a waste-way possibly 10 feet in width. There was a gate of perhaps about 3 feet in width.…The waste-way was on the north side of the dam, and close up against the ledge. I should think the top of the dam was somewhere in the vicinity of 100 feet. It was a very rough piece of work, but strong; a very ancient dam, constructed in the early colonial days.*

In 1642, soon after building his corn mill, Coytmore was named captain of the *Trial*, the first ship built in Boston, on its maiden voyage to the Azores and St. Kitts, a voyage of more than seven thousand miles. At the end of that year, he was off on another voyage. The will he wrote before leaving on the second voyage read as follows:

> *I Thomas Coytmor beeing in health of body beeing bound forth to Sea. And for as much as in thes vncertaine times its very difficult if not impossible to set a due valuation vppon temporal estates, therefore I conceive it most Convenient to Consider my estate in Sixteen partes.… Vnto my wife Six pts of the sixteene—son Thomas six sixteenth pts. As time are very hazzardous in Europe Therfore in case things should soe passe in England that my deere mother Katherin Coytmer bee deprived of her estate, then for her support I bequeath vnto her ffoure sixteenths of my estate to have as an annuity dureing her life, after which it shall returne to my child or children equally.*

Upon his return in 1643, Coytmore hired Abraham Hill, a carpenter from Malden, to run the day-to-day operations of his corn mill, which Hill did until his death in 1670. From 1657 on, Hill also ran an "ordinary" in his house in Malden that he called Hill's Tavern. This was the first of several taverns run by the Hill family. According to the 1924 proceedings of the Malden Historical Society, the last of these taverns, built in 1725, had George Washington and John Adams as guests on separate occasions.

Hill was in charge of ensuring that water flowed through Coytmore's corn mill so that it operated efficiently. This sometimes required a trip through the woods over rough trails to Spot Pond to open or close the gate at the dam. Court records document some of these trips. Sometimes his sons, Isaac and Abraham Jr., accompanied him. At other times, Hill sent his employees Nathaniel Ball or Francis Kendall. Isaac Hill and Nathaniel Ball gave the following accounts of these trips to Middlesex Superior Court in 1700 and 1701, respectively:

> *Isaac Hill of Malden aged about fifty nine or sixty years Testifieth and saith that when he was about nine or ten years old he this deponent lived with his father Abraham Hill Late of Malden formerly called Mistick Side and that then this deponent's father kept Mr. Thomas Coitmore's Corn mill on Mistick Side aforesaid Now being in Malden; and he this deponent used to goe with his father aforesaid to Spot Pond, where there was an old Sluce at the head of the Brook that runs from sd Spot Pond down to the corn mill aforesaid which sd Old Sluce being broken down this deponent with his father carried a New Sluce and set it down to stop the Water, and he this Deponent was Imployed by his father aforesaid to go to sd sluice to take up and shut down sd sluice as occasion required for the letting out and stopping the water for the use and benefit of Mr. Coitmore's mill aforesaid, and this, this deponent used to do at times for about the space of twenty years, and further this Deponent saith that he never knew of any molestation or disturbance given by any person.*

> *Nathaniell ball aged about seventy-five yeers testifieth That about fifty nine yeeres ago he lived with Abraham hill late of malden formerly called mistick-side: and then And severall yeers after he this deponant was improved by the sd Abraham Hill to go to spott pond to stop ye water And likewise to let out watter, as need required for the use of mr Thomas coitmors corn mill: which mill ye said Abraham Hill did then keep: And further this Deponant saith yt at ye said pond ther was both dam and sluce in Those times: & yt*

ye said Hill had ye whole benifit of ye watter of sd pond for ye use of said coitmors corn-mill & were never molested by any persons: & further this Deponant saith, That the sd Abraham Hill tooke the said mill of the sd mr Coitmore: and soe to Improve it for halfe the produce or profit of the said mill & was never molested or hindred of the water, but Injoyed it peaceably, & further say not.

In December 1645, Coytmore set sail again across the Atlantic, this time as captain of the four-hundred-ton *Seafort*. But disaster struck when the ship ran aground off the coast of Spain. Coytmore and eighteen others on board drowned. Coytmore was only thirty-three years old with an estate worth more than £1,200, a considerable sum at the time. Upon hearing the news, Governor John Winthrop called Coytmore a "right godly man and expert seaman." Edward Johnson, reverend of the Charlestown Church, said that Coytmore was "dearly beloved…a good scholar and one who had spent both his labor and estate in helping on in this wilderness work." Coytmore left behind his wife, Martha, but no children, as all three had died before him.

MARTHA (RAINBOROWE) COYTMORE

The corn mill on Spot Pond Brook now belonged to Martha Coytmore, but only until she remarried, which she did two years later. The man she married was none other than Governor John Winthrop. They had only been married a year when they had a child, Joshua. Less than a year after that, in April 1649, Winthrop died of "a feverish distemper." In January 1652, young Joshua died. Later that year, Martha Winthrop married again, this time to John Coggan, a merchant who had established Boston's first general merchandise store. John Endicott, Winthrop's successor as governor, presided over their wedding.

In 1653, John and Martha Coggan had a son, Caleb. But just five years later, John Coggan died in Boston. His estate included houses and the store in Boston, a farm in Rumney Marsh north of Boston, five hundred acres of land in Woburn and the corn mill on Spot Pond Brook. Coggan had acquired both the land in Woburn and the corn mill through his marriage to Martha.

In his 1657 will, Coggan gave one-third of his estate to his wife, with their son, Caleb, next in line to inherit this portion. At age twenty-one, Caleb was to inherit most of the estate. However, if he died before reaching

twenty-one (he died in 1672 at age eighteen), this property was to be divided between Coggan's daughters from his first marriage, Mary Robinson and Elizabeth Rock.

Martha Coggan was once again a widow and was despondent, having lost three husbands and all but one of her children. A family friend and master carpenter, Job Lane, showed an interest in the corn mill, and so she sold it to him. Shortly after this, in 1660, Martha suddenly died. Rumors quickly spread that, unable to recover from her grief, she had consumed rat poison. According to historian and biographer Adrian Tinniswood:

> *Martha, for whom the year 1660 also proved to be the End of Days. Martha's third husband, John Coggan, had died in April 1658, leaving her to raise their five-year-old son, Caleb, alone. Her Charlestown brother-in-law, Increase Nowell, on whom she had counted for support in the past, was gone. She was still only forty-one, with a personal fortune of over £1,000 and a life interest in a good part of Coggan's shops and farms. She expected to marry again. But no one asked her. At least, no one among the community leaders, no one to rank with Thomas Coytmore or John Winthrop or John Coggan. There was a farmer, "a mean man." And loneliness, a need for male company, a sense that time was passing, led her to encourage this nameless farmer. Only when things had gone too far did she have second thoughts. She grew depressed. And suddenly she was dead.*
>
> *The Boston magistrates were told of her death at a meeting on October 24, 1660. It was "not without suspicion of poson." In New Haven, the Reverend John Davenport heard the story from a man who had heard it from a man in the bay. "When she reflected upon what she had done, and what a change of her outward condition she was bringing herself into," he reported to John Winthrop, Junior, "she was discontented, despaired, and took a great quantity of ratsbane." Everyone believed Martha had taken her own life, a terrible thing then, as it is now. Worse, because the law showed no mercy to the victim. As it happened, just a week earlier the Massachusetts General Court had condemned suicide as a wicked and unnatural process and ordered that anyone found to have taken his or her own life was to be buried by the common highway and a cartload of stones was to be laid upon the grave "as a brand of infamy, and as a warning to others to beware of the like damnable practices." But the Boston magistrates didn't do that. Instead, they simply ordered that Martha be given a decent burial. They gave this woman who had been at the heart of the colony's life almost since its birth the benefit of the doubt. God have mercy on her soul.*

JOB LANE

Job Lane was now owner of the former Coytmore corn mill. Born in 1620 in a small town northwest of London, Lane had arrived in Massachusetts about 1656. He settled in Malden, which had separated from Charlestown and was incorporated as a town in 1649. Within a few years, Malden's selectmen hired Lane to build their first church and meetinghouse. He was paid £150 in "corne, cord wood and provisions, sound and merchantable att price currant and fatt cattle." As reported by Charles Edward Mann in the 1910 *Malden Historical Society Register*, Lane also built a house for John Coggan's daughter, Mary Robinson:

> *In 1657 Job Lane has a letter from his loving friend John Cogan. In 1660 Job Lane engages to raise the frame of a house for Thomas Robinson of Scituate upon land of Mary Robinson in Boston, his compensation to come from her mother, Mrs. Martha Cogin, it being the legacy due Mary Robinson by the will of John Cogin. In a deposition signed February 7, 1662, Edward Hutchinson and Joshua Scottow testify that they were present when Mrs. Martha Cogin sold Job Lane the mill in Malden, etc., and that he agreed to pay the legacies to Joseph Rock and Thomas Robinson or their children, due under the will of Mr. John Cogan.*

In July 1660, Job Lane married his second wife, Hannah (or Anna) Reyner, the daughter of Reverend John Reyner of the church at Plymouth. Through his wife, Lane became owner of land in England that she had inherited from her brother, Boyes Reyner, who died in 1643 fighting under Oliver Cromwell. Rent from this property allowed Lane to buy goods from England, such as fabrics, which were in demand in the colonies.

In 1660, as well as acquiring land overseas, Lane also acquired Martha (Coytmore) Coggan's corn mill on Spot Pond Brook. Abraham Hill, who had been hired by Thomas Coytmore, was still the mill keeper. By this time, Hill had been overseeing its daily operations for seventeen years. He was to continue in this role for another ten years. After Hill died in 1670, Lane hired Benjamin Whittemore from Malden to take over as mill keeper. After Whittemore left in 1684, Lane hired another Malden man, William Matthews.

DOROTHY AND EDWARD SPRAGUE

When Lane died in 1697, his estate consisted of "one dwelling house, barne, cornmill, stream, dams and ponds, with twenty-two acres of land adjoyning, and two acres of salt medow below Lewis his bridge and one quarter part of his lotts in the Comons of Malden."

In his will, he gave "unto my daughter Dorety Sprague, the east end of my dweling house I now live in to the chimney from the bottom to ye top with my mill and all my land adjoining and my salt marsh and land adjoining thereto to her and her haires forever, and likewise the west end of my dwelling house I doe give to her after my wife leaveth it."

Dorothy Lane was born in 1669, the fifth of Job and Hannah Lane's six children. In 1693, she married Edward Sprague of Malden, and eventually they had nine children. Sprague was well known in Malden as a "tithingman," responsible for keeping order in church during long services and ensuring that parishioners paid their share of dues to the church. He was the town's first treasurer in addition to serving as a constable, a captain in the Malden Militia and a town selectman.

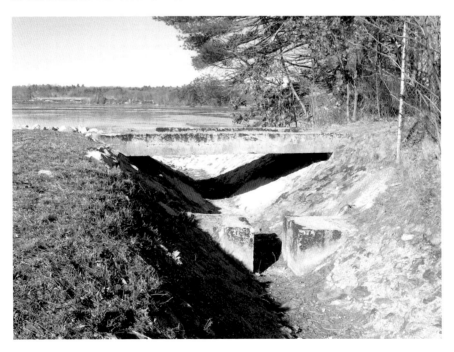

Spot Pond Brook dam and sluiceway in 2016 looking west across Spot Pond. *Photo by Douglas Heath.*

When Dorothy Sprague inherited her father's corn mill in 1697, her husband became the legal owner and took charge of its management, keeping William Matthews on as mill keeper. By this time, the mill had been providing corn meal and flour to nearby residents for fifty-six years. Theirs was still the only mill on Spot Pond Brook, and so the Spragues were unconcerned about who had the right to control its flow. This would change in 1707, when a second mill was built. From that time on, the Spragues were to devote much of their lives to defending their water rights.

To ensure an adequate flow of water to the mill, Sprague paid one of his workers, Joseph Perreum, to ride three miles on horseback to raise or lower the gate, as needed, at Spot Pond dam. Perreum described his trips to the dam in a July 1705 court deposition:

> *Joseph Perreum of lawful age, testifieth yt he hath lived with Edward Sprague of Malden at his mill Eight or tenn years, Since that he hath been Improuved by ye sd Sprague to stop the water at Spot Pond and let out as theire was occasion for the use of his mill, at lest a hundred times within sd time; and never was molested by any person, and wee used to raise ye water at Spot pond very neare to the height of ye dam at Spot Pond for the whole time above sd, for ye use of the said Sprague's Corn mill.*

Chapter 3

Decades of Conflict, 1707–1736

From 1640 to 1707, while the corn mill originally belonging to Thomas Coytmore changed ownership a half dozen times, the land between the mill and Spot Pond remained largely woods, with a scattering of farms. Peter Hay of Stoneham owned the land on Spot Pond Brook near Spot Pond dam. In his 1870 *A Brief History of the Town of Stoneham*, Silas Dean describes Hay's arrival in Massachusetts:

> *Hay was the first at the centre of the town....He was bound out as an apprentice in the city of Edinburgh, Scotland, but being dissatisfied with his situation, he resolved on leaving his master. He accordingly took passage for this country on board a vessel bound for Salem. On arriving in Salem, being unable to pay his passage...the captain of the vessel sold or bound him out to a man in Lynnfield, to work till he should pay his passage, which was something like six or seven years. After serving out his time he concluded to come into this vicinity and settle down....It is stated that he came over from Lynnfield with his axe and gun. It appears that he stood somewhat in fear of the Indians, although he purchased his land of them, at the rate of two coppers per acre.*

William Stevens wrote about Hay in his *History of Stoneham, Massachusetts*:

> *He was not only the owner of houses and land and men-servants and maid-servants, but he had a multitude of wives, no less than four. He*

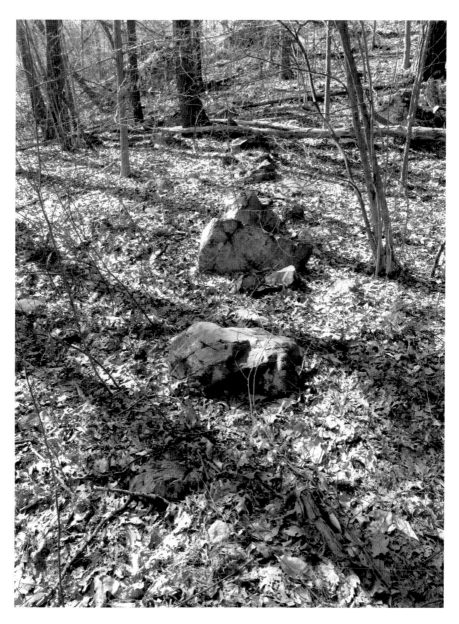

Remnant of a 1658 range line, which marked the northern boundary of Peter Hay's land, which became the site of a mill that operated on Spot Pond Brook from 1707 to about 1736. *Photo by Douglas Heath.*

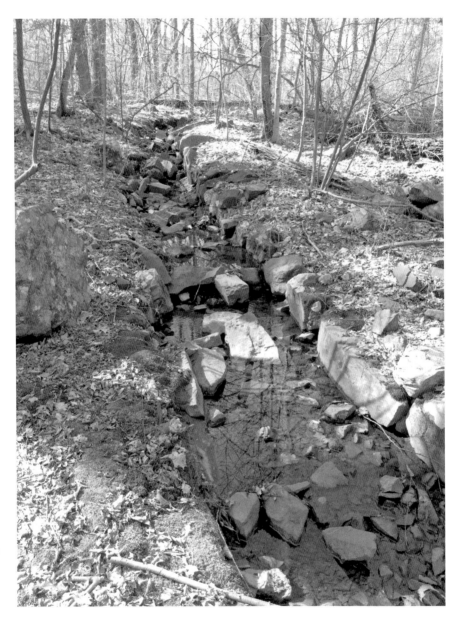

This stone-lined channel (millrace) in Spot Pond Brook was probably built by Daniel Green about 1707 for his sawmill. *Photo by Douglas Heath.*

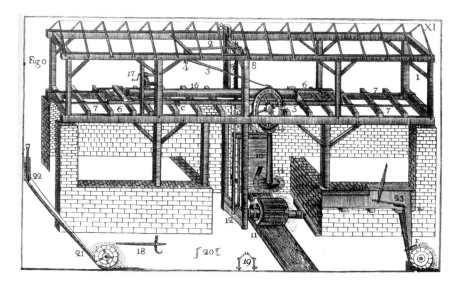

Oliver Evans published this illustration of a sawmill powered by a flutter wheel in 1795. The mill near Spot Pond operated by Daniel Green from 1707 to 1715 may have had this design. *From Oliver Evans's* The Young Mill-Wright and Miller's Guide *(Philadelphia, 1795).*

was one of the first selectmen when the town was organized. After having lived the life of a patriarch, so far as such a life was possible in the eighteenth century, and in Puritan New England, he died at the age of ninety in 1748.

In 1707, Hay sold three acres of woods beside Spot Pond Brook to James Barrett of Malden for £32 pounds and 5 shillings. The deed describes the property as bounded on the north by a range line, one of the east–west survey lines that had been established by the Town of Charlestown in 1658 and marked by stone walls. Stevens described how the range lines were laid out: "For the devision of the wood and timber, we conceave the whole to be divided into ten equall parts, and the devisions to runn from Mistick bounds to Reading bounds the longest way."

After buying the land, Barrett leased it to Daniel Green of Malden, who built a house and a barn, as well as a sawmill on Spot Pond Brook. Like most sawmills in early New England, this mill was built of wood and stretched across the brook, supported by stone foundations on either side, with a millrace passing underneath. This millrace still exists today. Lined with stone, it is more than 140 feet long and 3 feet wide. The mill probably

used a vertical "flutter" wheel, so called because of the sound made by its blades as they were turned by the flowing water. According to Larkin's *The History and Future of Naturally Powered Buildings*, this type of wheel was used to power many early sawmills. The circular motion of the wheel was converted to a reciprocating motion at the saw blade inside the mill.

EDWARD SPRAGUE VERSUS DANIEL GREEN

Green soon ran into the problem of running a mill without being able to control the flow in Spot Pond Brook. Although he would not have known, his problem had a history dating back to the earliest mills of the eleventh and twelfth centuries in England. Wherever millers shared a stream, they inevitably came into conflict with one another. The usual conflict was a result of one miller raising a dam or weir to increase the head of water to drive his waterwheel, an action that often drastically reduced flow to downstream mills.

However, Green's problem wasn't the result of a dam being raised; rather, it was his lack of authority to lower it. This right was in the hands of Edward and Dorothy Sprague, owners of the Malden corn mill three miles downstream and holders of the Coytmore privilege, the water right that dated back to 1640. In a January 1885 article in the *Melrose Journal*, local historian Artemus Barrett wrote about the Spragues' control of both Spot Pond Brook and Spot Pond:

> [F]or more than a hundred years the mill was in possession of this branch of the family, and they exercised complete control of the same, commencing in the seventeenth and running through the eighteenth and into the nineteenth centuries. For more than forty years of which time this pond was in constant litigation, and the Spragues, who were very tenacious of their rights, valiantly defended the same, contending not only with some very determined individuals, but with towns, and even the Commonwealth, which took the matter in hand.

The same year that Green began running his sawmill, 1707, he was forced to leave it idle because of low flow in Spot Pond Brook. Even though flow was also low at the Spragues' corn mill, mill keeper William Matthews was in no rush to lower the gate at Spot Pond dam because, for the short term, he could

use water from the Spragues' large millpond. But Green did not want to wait. Leaving his mill idle meant no income. Instead, he took an expedient, but illegal, approach to the problem. On a cold day before Christmas 1707, he walked to the dam with a shovel and knocked down part of the earth embankment. Water immediately began to flow into the brook, and he returned to his sawmill.

Edward Sprague discovered what Green had done and filed charges in May 1708 in the Inferior Court of Common Pleas. According to the charges, Green "on ye Twenty Second of December last past did by force and arms enter upon a Dam of the Plantiff in his possession at a place known by the name of Spott Pond in the Township of Charlestowne in the County aforesaid and then and there Digged up and pull down the Dam and Lett out the water which ye pet has preserved for the use of his grist mill."

The charges included a second incident on March 18, 1708, when Green "did enter upon the Dam aforesaid and did then and there pull up the Sluice boards and carried away the boards which ye petitioner had set down to preserve the water for the use of the grist mill." Sprague asked the court for £60 in damages.

By turning to the court to address his claims against Green, Sprague was using a legal system that had only been in place in Massachusetts since 1692. The system was based on the common law system established in England in the late twelfth century that allowed citizens to press charges against one another without involving the reigning monarch. Beginning in 1692, the Inferior Court met quarterly at various locations in the colony to handle civil cases. The Superior Court of Judicature was the highest appeals court and the trial court for capital criminal cases and civil disputes over £10. Over the years, both courts were used by the Sprague and Green families to settle claims of trespass, property destruction and debt related to mill operations along Spot Pond Brook.

But others besides Sprague and Green had an interest in flow into and out of Spot Pond. The 1708 charges against Green prompted the selectmen of Charlestown to write to the court, claiming that their town owned Spot Pond, giving them the right to have a say over how the dam was operated:

> *We the Selectmen of Charlestown with submission take leave to inform your honors that said pond premises aforesaid hath been always claimed by the inhabitants of Charlestown as their proper right and property in general…and neither Edward Sprague nor Green nor any other particular person hath a title to it but the inhabitants of Charlestown and wee shall be upon legall notice given us thereof ready to defend our title against all that*

shall lay claim thereto before your honors or any others of Her Majesty's Courts that shall have proper cognizance of the matter to their satisfaction. We doubt not.

Edward Sprague and Green appeared in court on October 27, 1708. Green told the jury that he had a right to go onto Sprague's property because the part of the dam that he "pulled down" was on land that he was leasing from a local farmer, John Dexter. The court, however, determined that the dam was not on Dexter's property and was owned by Sprague (and not Charlestown), and ordered Green to pay Sprague £8 plus court fees. Green appealed the decision to the Superior Court of Judicature in Charlestown, which agreed that his defense had some merit and reduced his fine to £4. In the end, both parties won. Edward Sprague strengthened his claim to water rights in Spot Pond Brook, and Daniel Green's penalty was reduced to a token amount.

As the eighteenth century got underway, the population of Charlestown End (incorporated as Stoneham in 1725) continued to grow, and the demand for lumber was high. Flow in Spot Pond Brook apparently was adequate for Green's sawmill because no further complaints appear in court records. In December 1708, Green married Mary Bucknam of Malden, and their first child, Esther, was born in 1709. They went on to have five more daughters and a son.

Green stopped managing the sawmill sometime before 1715, the year that his old adversary, Edward Sprague, died. In 1719, Green and his family moved to a nearby farm, which he bought from his older brother, Henry. Moving forward from his days of fighting charges of trespass and property damage, Green eventually became a distinguished citizen of the new town of Stoneham, serving as a selectman and deacon of its first church. However, like many landowners at that time, Green was also a slave owner. In his will, his "property," which he left to his wife, included an African American woman and her children. Green died in 1759 and was buried at Stoneham's Old Burying Ground.

After Edward Sprague's death in 1715 at age fifty-two, his widow, Dorothy Sprague, continued to run the Malden corn mill with help from her son Timothy, the fourth of her nine children. That same year, James Barrett sold the sawmill, house and barn near Spot Pond to Stephen Richardson Jr. of Woburn and John Vinton of Charlestown End for £45.

Richardson and Vinton converted the sawmill to a corn mill. Over the next seven years, the value of the mill property rose considerably, suggesting that

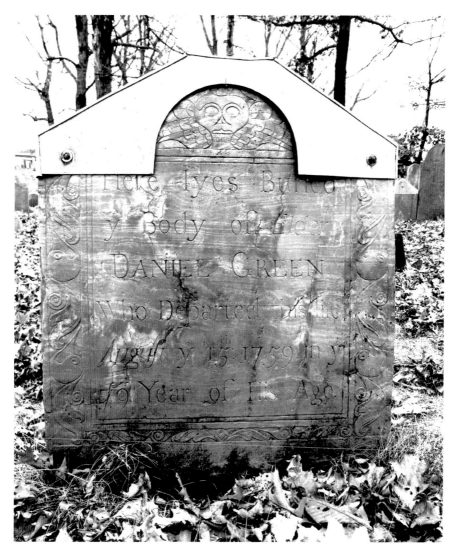

Gravestone of Daniel Green (1681–1759) at the Old Burying Ground in Stoneham. *Photo by Douglas Heath.*

flow in the brook was not a significant issue. In fact, it appears that Richardson and Vinton got along quite well with the Spragues because they sold the mill in 1722 to twenty-one-year-old Timothy Sprague. The sale price was £240, yielding a tidy profit for Richardson and Vinton. The sale included "a Certain Corn Mill & Small Dwelling house standing thereon bounded and followeth North on the Range line."

DOROTHY SPRAGUE VERSUS JOHN GREEN

With this purchase, the Sprague family owned the mills at either end of Spot Pond Brook. However, only a week later, Timothy Sprague was discussing selling the corn mill near Spot Pond to Daniel Green's cousin, John Green of Malden. John Green visited Sprague in his Malden home and offered an additional £50 for the right to control flow at the Spot Pond dam. Sprague turned to his mother, Dorothy, for a decision. She flatly refused the offer and, according to court records, said, "It is my own proper right given me by my honored father and I will not convey it [the Coytmore privilege] to any person whatsoever." John Green decided to buy the mill anyway. Had he been able to look into the future, he might have followed his cousin's advice and not bought the mill without water rights.

Later that year, two of John Green's friends, Isaac Wilkinson and Joseph Douglass, visited Green at his mill. Douglass liked what he saw and proposed building a fulling mill (a mill that cleans wool cloth to eliminate oils and dirt and make it thicker). Green offered Douglass the use of the brook for £4 per year. Douglass asked "whether ye water course continued good all the year." But when Green replied that the Spragues, not he, controlled flow at the dam, Douglass declined Green's offer.

John Green soon found himself in the same position as his cousin Daniel: faced with a dry brook and an idle mill. Green knew from his cousin's experience that he could not simply break down the Spot Pond dam. He decided, instead, to create a millpond for his mill like the one at the Spragues' Malden mill. Green reasoned that water from his new millpond could be used to run the corn mill for short periods when water in Spot Pond Brook was low. So, in late summer of 1722, John Green and a few workers, including sixteen-year-old Andrew Evans, built a crude dam with boards and gravel just upstream of Green's mill. But even with this millpond, Green found that he often needed more flow from Spot Pond.

One day in April 1723, young Evans brought Green a sack of corn to be ground into flour. Green told him that he'd be glad to fill the order, but only if Evans went to Spot Pond dam and "let down the water." According to 1726 court testimony by Evans, Green told him that "he saw Timothy Sprague go homewards just now; but you may look about & if you see anybody do not let out the water, but come to the mill again, still the Deponent not being willing, said Green told me the Deponent that if anybody did catch me drawing water, they could not hurt me because I the deponent was under age."

Another boy, fourteen-year-old Lawrence Jackson Harris, told the court a similar story, saying that he had gone to Green's mill to have grain ground into flour. He had been waiting some time when Green appeared and told Harris that

> *if he would go and pull up the Dam & let out the water he should have his corn first ground and the sd Green further told the Deponent that he should look about, & if he saw any body he should not let out the water, but run as fast back again to the mill as he could, and the Deponent furth saith that the said John Green went with him several times a considerable part of the way towards the Dam, & sd Green told the Deponent whenever he bid him let out the water nobody could hurt him because nobody could hurt Boys.*

In July 1726, Dorothy Sprague sued John Green in the Inferior Court of Common Pleas in Charlestown for £100 in damages, stating that Green "erected and made and ever since continued a certain Dam of boards and Gravel and such like stuff across the water course…stopped and hindered the water course…from running freely to [my] mill pond." Sprague complained that she could grind only one-third the amount of Indian corn that she had previously ground. Green hired two prominent Boston lawyers to defend him. One of these, Robert Auchmuty, later became a judge on the Admiralty Court for New England. Decades later, his son, Robert Jr., would also serve on this court and would become part of John Adams's defense team at the Boston Massacre trials. With help from his lawyers, Green argued that as owner of a mill, he had the right to control the flow of water to the mill and, therefore, had a right to build a dam. The jury sided with Green and ordered Sprague to pay £8, 19 shillings and 10 pence to cover court costs.

Dorothy Sprague filed an appeal in the Superior Court of Judicature of Middlesex County and won. The court reversed the lower court's decision and ordered Green to pay court costs of £4, 3 shillings and 9 pence. But it was only a partial victory. Sprague had only recovered a fraction of her claim of £100 in damages and saw that she could not count on the courts to side with her family on questions concerning water rights. But she did not live long enough to test the courts again. The following year, in 1727, she died at age fifty-seven and was buried next to her husband at Bell Rock Cemetery in Malden. Her son, Timothy Sprague, inherited her Malden corn mill and, for the next decade, became locally famous for his court battles.

TIMOTHY SPRAGUE VERSUS JOHN GREEN

Timothy Sprague was born in 1700, the fourth of the Spragues' nine children. From an early age, he showed an interest in helping run the Malden mill. Because of his commitment to the family business, his parents decided to leave the mill to him. He was twenty-seven when he inherited the mill and the Coytmore privilege, which gave him the exclusive right to control flow at the Spot Pond dam. As in past years, when water was too low at his mill, he traveled three miles upstream on horseback to check the dam and look for vandalism. He soon became convinced that he needed to constantly watch the dam and decided to "dig a cave to hide men in, in the day time, so that he might be able to know and convict the trespassers." Still not satisfied that the dam was protected, he built and moved into a guardhouse beside the dam. The stone foundation of the guardhouse still exists today.

In December 1727, according to Commonwealth of Massachusetts Court Records, he sent a petition to Lieutenant Governor William Dummer of the Massachusetts Bay Colony, urging him to sponsor a bill that would strengthen the law against trespassing and increase penalties for property damage and loss of business. Using the third person, Sprague wrote:

> *He hath apprehended two persons under or about the age of 14 years, who were letting out his water at the said dam, and convicted them before lawful authority who at the time of such conviction, confessed that they were ordered to do so by one John Green of Stoneham, and who has been a notorious offender in the premises…the damages which he recovered were so small, being but three shillings to the same, are by no means a recompense to the damages he hath sustained.* [He and his workers] *have really been in danger of their lives when watching at the said dam in the night time, the persons coming there being several in number and armed with clubs and other weapons, who, when they are discovered make off without speaking, so that the petitioner could not discover them so as to prove who they were.*

The following August, Sprague sued John Green for £20 in the Inferior Court of Common Pleas in Charlestown for building a dam in Spot Pond Brook without his permission. Sprague claimed that as a result of this dam, he had only been able to grind ten bushels of Indian corn that summer instead of the £20 he had anticipated. As he had argued before, Green

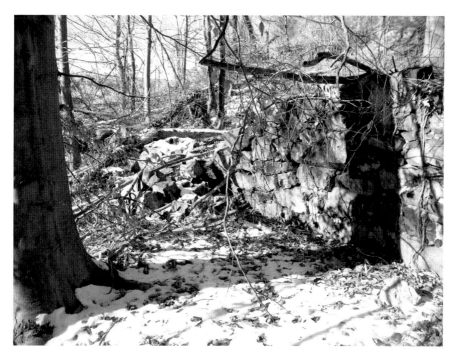

Ruins of Timothy Sprague's guardhouse next to Spot Pond dam in Stoneham. *Photo by Douglas Heath.*

responded that owning a mill gave him the right to build a millpond. The jury agreed with Green and ordered Sprague to pay Green £6, 13 shillings and 6 pence to cover court costs.

Sprague filed an appeal to the Superior Court of Judicature in Charlestown, where he argued his case in January 1729. Sprague insisted that when Green bought the corn mill near the Spot Pond dam, they had agreed that Green did not have water rights in the brook. However, this agreement was not put into writing.

Before the court made a ruling, Green offered to pay the jury to travel to his mill to see the situation for themselves. However, in July, Green withdrew his offer. The jury reversed the lower court's decision and awarded Sprague "the sum of five pounds money damage and cost of Courts taxed at twenty-one pounds, eighteen shillings and ten pence." Although Sprague won the appeal, Green did not remove his dam.

Less than a year later, in August 1729, Sprague was back in court complaining that Green's dam had reduced flow in the brook so that he was only able to grind one-third of the grain he normally processed. Sprague

said that the last court ruling had awarded him far less than he needed to cover his losses. He again challenged Green in Superior Court; this time, Green was ordered to pay Sprague £14 pounds and 17 shillings.

In 1730, Sprague, who had been dividing his time between his house in Malden and the guardhouse in Stoneham, decided to rent the guardhouse to his cousin, Abigail (Sprague) Call. That spring, she and her husband, Samuel Call, a shoemaker, and their four children moved into the house. Their son Samuel Call Jr. stated in a 1798 court deposition:

> [I] *lived in a house belonging to Timothy Sprague, situated not more than seven or eight rods from the head of the stream which issues from Spot Pond being the stream on which said Spragues Mills in Malden stood. I lived there with my father until the winter of the same year, that I well remember that on the said stream at the edge of the pond were placed a quantity of loose stones, some earth & leaves, these materials were several times removed in the night time. Mr. Sprague as often came up from Malden with a man and replaced the same.*

In March 1731, Sprague again took Green to court, saying that Green

> *with force and arms at Stoneham entered into the Plaintiff's watter course or stream…and with a certain dam or Sluce near to said dam both made of boards & gravel and such like stuff across the watter course or stream… obstructed hindered and Stoped the Plaintiff's watter course…from running freely from the Plaintiff's Mill Pond in Stoneham…called Spot Pond to the Plaintiff's Mill pond and Mill…in Malden…and has ever since continued upheld & repaired and maintained the same across the watter course or Stream.*

Sprague asked for £200 in damages, but for the second time, the Inferior Court ruled in Green's favor, ordering Sprague to pay court costs of £2 and 5 shillings.

Sprague sued Green again in 1732 for £200. Green's lawyer, Robert Auchmuty, argued that the case had already been heard and asked that it be thrown out. But the case went ahead, and Green was awarded £2 and 5 shillings. Again, Sprague won on appeal. A pattern emerged of the Inferior Court favoring Green, while the Superior Court favored Sprague. But whichever side won, the payments awarded by the courts were so low that it was hardly worth the effort of going to court.

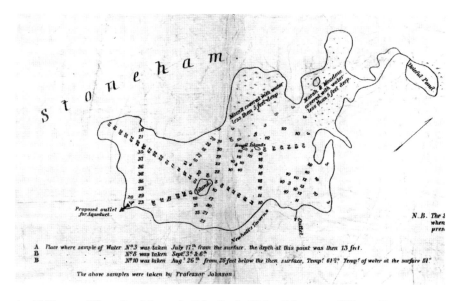

An 1845 map of Spot Pond drawn by John Jervis, Walter Johnson and Henry Tracy showing water depths ranging from less than five feet in the north part of the pond to thirty-eight feet in the south. *Boston Public Library.*

Meanwhile, Sprague was fighting a battle on another front. He had drawn the ire of Stoneham residents who owned low-lying areas beside Spot Pond, including farmers who harvested hay and various tradesmen. They were upset because Sprague's control of the dam at the head of Spot Pond Brook caused their land to either flood or become too dry. The 1845 map of the pond shows areas of "Marsh & Meadows covered with water less than 5 feet deep." In early 1732, blacksmith John May, "husbandman" Thomas Gerry and carpenter Grover Scollay made a breach in the dam four feet deep and twenty feet wide. Sprague's response was predictable: he sued them for £300. He accused them of tearing down the dam "with force & Armes." The defendants claimed that "their Low Lands and Meadows in Stoneham…are in great measure overflowed and spoiled to their Grievous Damage by reason of a Stoppage in Spot Pond Occasioned by a bank in the Land of Timothy Sprague of Malden Miller." In July 1732, the court ruled in Sprague's favor and ordered the three Stoneham residents to pay Sprague £6 in damages.

Sometime in the midst of these bitter battles about water rights, Sprague nearly lost his life. While repairing the Spot Pond dam, which had been vandalized the night before, a man named Jabez Allen, who lay hidden

in the woods, shot at Sprague. However, the musket ball passed between Sprague's legs and made a hole through his leather apron. According to historian Artemus Barrett, in a January 31, 1885 article in the *Melrose Journal*:

> *For this offence, it is said, Allen was sent to prison, there to be whipped and to sit upon the gallows for several hours with a rope around his neck. While sitting there in his musings, he composed the following doggerel verse:*

> *"Some call me Jaby Allen*
> *And others call me Medes,*
> *And here I sit upon the gallows*
> *For all my evil deeds.*

> *O that I were the Judge,*
> *Now in poor Jaby's case!*
> *I'd have poor Jaby out of jail,*
> *And have old Tim Sprague in his place.*

> *Old Cambridge is a mighty place*
> *For learning and for knowledge,*
> *For some they whip and some they hang,*
> *And some they send to college."*

Silas Dean included this story in his 1870 *History of Stoneham*, except, in his version, Sprague came upon Allen breaking the dam. While trying to flee by boat to Great Island in Spot Pond, Allen turned around and shot Sprague with buckshot, wounding him in his legs.

In 1733, the battles between Sprague and Green finally ended when the Superior Court of Judicature in Cambridge held a hearing to decide whether the fact that Green owned his mill gave him the right to build a dam or to alter the flow in Spot Pond Brook by other means. After a long deliberation, the jury decided to support Sprague's water rights, which were derived from the Coytmore privilege dating back to 1640. They ordered Green to pay Sprague £6 plus court costs of £25 and 3 shillings. Green appealed the ruling all the way to the Council of King George II, where he was dismissed with the statement that "an appeal in this case does not lye." Thus ended the epic legal battles between Timothy Sprague and John Green.

On August 29, 1736, John Green died after a period of being "exercised with pain & bodily disorders." He was sixty-six years old. In his will, dated

June 24, 1736, he left his estate to his wife, Isabel. The next year, she sold the property to Anthony Hadley of Stoneham for £206. The deed included a house and barn but did not mention a mill. By this time, the mill may have been abandoned. Hadley was a farmer and may have had no interest in operating a mill. After thirty years of existence, Stoneham's first mill passed into obscurity. Today, only the millrace and scattered foundation stones remain.

Timothy Sprague was now thirty-seven and married to Mary Legg of Malden, who was eleven years his junior. But two years later, in 1739, Mary died, probably in childbirth. Twenty years passed before Sprague married again. In 1759, he married Sarah Conery, thirty-eight years his junior. The following year, they had a son named Matthew Whipple, followed by a second son, Timothy Jr., and a daughter, Sarah. They lived in Malden near their mill property, which now had two fulling mills as well as the original corn mill. Sprague still owned the guardhouse beside Spot Pond dam, but after his cousin moved out in 1731, it is unclear whether he rented it to others or occupied it himself. The next record of someone living there is in 1764, when Sprague rented the guardhouse to John Batts, a local cordwainer (shoemaker). Batts moved in with his wife, Hannah, and infant son, John, and paid an annual rent of £5, 1 shilling and 4 pence. The lease included provisions that he "look well after Spot Pond Dam and all the said Timothy Sprague's lands in Stoneham as shall be best to the sd Timothy's advantage," care for one or two cows, "leaving all the Dung ye shall be made on the sd leased lands," and repair the fences around the fruit trees.

Timothy Sprague's Strange End

In early October 1765, a poisonous snake bit Timothy Sprague's arm while he cleaned the sluice at Spot Pond dam. Knowing that he was dying, he quickly wrote a will dividing his property, valued at £755, between his wife and young children. He gave most of his property—including his corn and fulling mills, pastures, woodlots, orchards, marshes and uplands in Malden, as well as the guardhouse, barn and nine areas in Stoneham—to his sons, Matthew Whipple and Timothy Jr., to be held in escrow until they reached twenty-one. The corn mill went to Matthew, and two fulling mills went to Timothy Jr. The property near Spot Pond dam, which was divided equally between them, also included "ye Watercourse, Dams and Sluices, also ye

Pond and Dam and Waste at Stoneham." Sprague left his infant daughter, Sarah, a mere £26, 13 shillings and 4 pence to be held by her brothers until she was eighteen years old.

Sprague left a long list of items and instructions for his wife. Sarah was to receive £5, 6 shillings and 8 pence to be paid in four payments each year until she died or remarried. He also gave her six cords of wood, six bushels of meal, five bushels of winter apples, a cow and "liberty to keep a hog at ye door." He also said that for the rest of her life, she could use the two easterly chambers of his house and one half of the westerly cellar. He went so far as to describe where she could go in the house and on the property, including permission to bake and wash in the kitchen, go to the well for water and maintain the garden. He listed household items that she could use, including, among other things, beds, a chest of drawers, a trunk, chairs, pewter platters, a brass kettle and warming pan, an iron pot, earthen plates and tea dishes, a fire shovel and tongs, an hourglass and looking glass, one pail, a beer barrel, washing tubs, a toasting iron and gridiron, a hook trammel, a coffeepot and "sermon books, Bater's Works excepted." Strange as it appears today, Sprague's will was not unusual at that time—it was common for men to provide their wives with annual supplies of such things as barrels of cider or apples and bushels of vegetables or corn and rye.

One of the items in his list of possessions, the pewter platters, is particularly noteworthy. It wasn't until the middle of the seventeenth century that pewter came into general use among the more prosperous farmers in England, and then only as several pieces for use on more formal occasions. For regular use, a wooden trencher (a tray or plate used for cutting) was used by middle-class families until well into the eighteenth century. This was true both in Old England and New England. It is mostly through wills and the settlement of estates like Sprague's that historians know that some early settlers in the Massachusetts Bay Colony owned pewter (as well as silver).

Sprague's inventory also lists two African American slaves, Cristifor and Jethro. No records exist showing whether they were freed after Sprague died or whether they were forced to continue working for his wife and children.

Before the Revolutionary War, many wealthier families in New England owned slaves. Massachusetts had been the first colony in New England with slave ownership and was a center for the slave trade throughout the seventeenth and eighteenth centuries. According to a state census, in

1765, the year Sprague died, there were 5,779 slaves in Massachusetts. By 1790, there were none, mainly due to a successful abolitionist movement and an economy that was not dependent on slave labor to the extent of southern states. However, slavery was not abolished in Massachusetts until the Thirteenth Amendment was ratified by the state in 1865.

Sprague appointed his brother Joseph Sprague, a blacksmith living in Leicester, sixty miles west of Malden, to be executor of his will. His wife, Sarah, was apparently unable to care for all three children because Timothy asked Joseph to take custody of Matthew and Timothy Jr., while their infant sister, Sarah, would stay with her mother.

Timothy Sprague died at Malden on October 10, 1765, and was buried in a crypt at the old burial ground at Edgeworth in Malden. Nine months later, probate judge Samuel Danforth in Cambridge wrote to Captain Jonathan Green of Stoneham, who had been a friend of Timothy Sprague. Danforth said that Joseph Sprague appeared "to be very uneasy with the present situation of affairs respecting them [the boys] & their interest. I should be glad to have matters so ordered as to quiet all parties concerned." He also thought that the boys should return to Malden. Green agreed to care for the boys and, in July 1766, rode his horse to Leicester, taking along an extra horse and "chair" to carry the boys. Green also agreed to take care of baby Sarah from July 1768 to April 1769.

In April 1769, Captain Ebenezer Harnden, a friend of the Sprague family, assumed guardianship of the boys until 1782, after both boys reached maturity. Harnden served as Malden's moderator and treasurer and also represented the town in the General Court, speaking against the Stamp Act a decade before the Revolutionary War. Green and Harnden may have become guardians to the boys for financial gain because all costs of caring for the children were covered by Timothy Sprague's estate.

Timothy Sprague's story did not end with his death. According to historian Artemus Barrett in an 1885 article in the *Melrose Journal*:

> *Dr. Warren of Boston examined it* [Sprague's body] *in 1823, fifty-eight years after his death and found the body sound, it not being decayed, and the features of his face were in perfect condition. An account of his examination was published in Boston scientific papers. Many, from curiosity to see him, visited and broke open the tomb, and left it so that anyone could have access to it. I have heard it said that some medical students from Boston came there in a boat, and after remaining a short time, saw the sexton coming, fled to*

their boat after having secreted a bundle in some bushes, which was seen by the sexton, who went for it and found a bag which contained the head of Timothy Sprague, which they had severed from the body.

Barrett wrote that Malden town officials ordered that Timothy Sprague's body be reburied, but his final resting place is unknown.

SPRAGUE'S CLOSING CHAPTER

In 1782 and 1784, brothers Matthew and Timothy Sprague Jr. sold the Malden corn mill, which had been in their family since 1660, and the two fulling mills on the same property, as well as their father's guardhouse and nine acres in Stoneham, to a local miller, Samuel Tufts III. With these sales, the brothers no longer owned any mills on Spot Pond Brook and, therefore, had no reason to retain water rights to the brook. In August 1792, they legally transferred the water rights (the Coytmore privilege) to Tufts. As stated in the deed signed by Timothy Sprague Jr., "I do hereby remise, release and forever quitclaim, etc. to Samuel Tufts, his heirs, etc. all the right & title I ever held to the Dam, Pond and Sluice aforesaid, with all the privileges thereto belonging."

First Mills on the Ravine, 1792–1813

EBENEZER BUCKNAM

Until 1792, mills had only existed at the upstream and downstream ends of Spot Pond Brook. The three-mile section between these, which contained a steep ravine, had remained woods and farmland. This ravine is labeled "gorge" on Perry's 1934 map (see page 15). In 1769, Ebenezer Bucknam, a local yeoman and cooper, bought fourteen acres of land along this section of the brook from Jonathan Green (former guardian of Timothy Sprague's sons) for £46, 13 shillings and 4 pence. Two decades were to pass before Bucknam took advantage of the water power along this stretch. In 1787, his father, Deacon Edward Bucknam, bought two acres of pastureland near the Spot Pond dam, by then known as "the old dam," from Anthony and Sarah Hadley (Timothy Sprague's widow) for £3 and 12 shillings. With this purchase, the Bucknam family owned all of the land along Spot Pond Brook in Stoneham except for one eight-acre lot belonging to Ebenezer Barrett (see page 76).

Ebenezer Bucknam was born in 1744 in Stoneham. At age eighteen, he married Mary Hay, whose family had owned property and worked on Spot Pond Brook. Her paternal grandfather, Peter Hay, had been an early owner of land near Spot Pond dam and had sold the sawmill land to James Barrett in 1707 (see page 33). Her maternal grandfather, John Green, owned the gristmill that was built there in 1715 by Stephen Richardson and John Vinton (see bottom of page 36). Mary died of unknown causes in 1782 at age forty.

Four years later, Bucknam married another local woman, seventeen-year-old Rachel Lovejoy. She had nine children, the last of whom was born when Bucknam was sixty-three.

Bucknam served in the Revolutionary War as a private and a corporal. According to Hurd's 1902 *Representative Citizens of the Commonwealth of Massachusetts*:

> *He was one of the Stoneham minutemen, and marched with the Stoneham company under Capt. Samuel Sprague on the eventful April 19, 1775. In the battle of Lexington, a ball grazed his head, cutting the hair, which never grew again, just above the left ear. He was in the battle of Bunker Hill, June 17, 1775, and all through the Revolutionary War, fighting with general Stark at Bennington and under General Gates in the battle of Stillwater, and was present at the surrender of General Burgoyne at Saratoga. His homestead was on the north side of the road, one quarter of a mile east of Spot Pond. Here he raised a family of fourteen children. A large pine tree now marks the spot where stood the house, and around it still, in good condition, the cellar walls. It is now in the Metropolitan Reservation.*

In 1792, the same year that the Sprague brothers sold their Malden corn mill to Samuel Tufts, Bucknam decided that it was time to build mills in his ravine. He hired Nathan Lynde of Malden to build a 16-foot-wide bridge and two dams on Spot Pond Brook, one at the top of the ravine and a second dam about 120 feet downstream within the ravine. At the second location, Lynde also built a sawmill for Bucknam. This sawmill was housed in a three-story wooden building perched on the north bank of Spot Pond Brook. It had a vertical overshot waterwheel, powered by water flowing along a wooden flume from the lower millpond.

In 1792, Ebenezer Bucknam sold a one-acre lot that crossed the ravine below his sawmill for "fifteen pounds of lawful silver money" to John Rand Jr., a tobacconist from Boston who presumably wanted to build a snuff mill. The deed included a provision that Rand

> *could not set up any Mill or Dam between where said Saw mill Fraim [Frame] now is and said piece of Land hereby sold to said Rand nor hinder said Rand from flowing [flooding] his the said Bucknam's land between where the said Saw mill Fraim now is and the Premises, provided that the top of the water said Rand and his Heirs or Assigns "stop" do not rise to be within two feet of the bottom of where said Saw mill South Cill [waterwheel base] now is.*

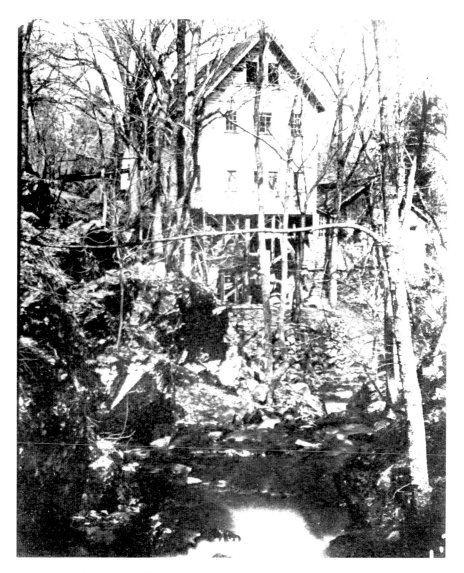

Ebenezer Bucknam's sawmill, which operated from 1792 to about 1870 and was last used to power the Grundy Brass Foundry. The foundry is visible below the sawmill at the far right. Photo taken about 1880. *Stoneham Historical Society.*

This deed restriction shows the concern that Bucknam had about the potential effect that a dam for one mill could have on a nearby mill. By stopping Rand from building a mill dam to increase the head of water to drive the waterwheel, Bucknam was preventing a situation where water might back up into the tailgate of his upstream sawmill, slowing or stopping

its waterwheel. However, there is no evidence that Rand ever built a mill on his lot. Parker Perry's map of Haywardville in 1860 (see page 15) shows a chocolate mill on this site, but there are no mill foundations on the wall of the ravine nor any deeds or photographs giving evidence of such a mill.

Not all of Bucknam's time was spent managing his mill. In 1794, he became Stoneham's surveyor of highways. His duties were described in a 1794 town document:

> *To Mr. Ebenr Bucknam Surveyor of highways in Stoneham: Sir you are allowed the sum of 29 pounds 1 shilling…to be worked out on the highways in Stoneham beginning at Woburn line from thence on the rode to the Meating house by Dean Edward Bucknam and also from the corner near Lt Bucknams on the rode to Medford line near Samuel Hadleys and from the corner of Spot Pond near Ebenezer Bucknams on the rode to Malden Line near Mr Jabez Lyndes and also the sum of ten shillings for you to work out your Self of the nonre[si]dence on [the] rode the wages to be worked out agreeable to the Vote of the Town. Stoneham, April 16th 1794.*

In another town document, Bucknam wrote an account of taxes that he owed in 1795, making an exception for two acres of woodland that he sold to Jonathan Tufts and two acres that he sold to John Rand:

> *Stoneham May 1795*
> *Ebenr. Bucknams Invoise*
> *one Swine 2 Cowes 17 acors of Land*
> *one House 1 Barn 2 acors of woodland*
> *not to be rated for sold to Jonat Tufts*
> *of Medford & 2 acors sold to Mr John Rand*
> *of Boston. This land that is mensiond hear*
> *is to Be Charged to them In Tax*

That same year, 1795, Bucknam gave Nathan Lynde one-quarter ownership of his sawmill and dam, "in consideration of the money, work, timber, boards and other stuff…in making a sawmill…and also making dams for the stoping of water." The men agreed that Lynde would operate the mill for the first week of every month and Bucknam for the remaining weeks. Three years later, in 1798, Bucknam sold his three-quarter share of the sawmill to Edward Rumney, a Boston merchant, for seventy-five dollars. Lynde held on to his quarter share for another seven years.

WILLIAM MICKLEFIELD

As well as selling his part of the sawmill, Bucknam leased a half-acre of land at the top of the ravine (upper millpond on Perry's map on page 15) to tobacconist William Micklefield, who built a mill for grinding tobacco into snuff. At this time, about 1798, the snuff industry in New England was about fifty years old. Micklefield's mill straddled Spot Pond Brook and was probably like other snuff mills of its time. These used a set of polished iron pestles about two feet long and six inches in diameter. The pestles rolled tobacco in large mortars made of oak or cast iron.

Power for Micklefield's mill was supplied by a fourteen-foot-diameter horizontal tub waterwheel, which turned a vertical shaft and the grinding machinery. This wheel was called a "tub" wheel because it turned in a circular depression or "tub," which was lined with wood. A horizontal wheel set in the streambed was the simplest way to transmit power from a stream

Snuff grinding machinery at the Gilbert Stuart Birthplace & Museum in Saunderstown, Rhode Island. Built in 1750, this was the site of the first snuff mill in the American colonies. *Photo by Douglas Heath.*

to a waterwheel. This type of mill required few gears and was easy for a miller to maintain. The hemispherical depression where the waterwheel once turned can still be seen in Spot Pond Brook.

One year after starting his snuff business, Micklefield bought the snuff-mill property from Bucknam for $130. An 1800 deed records this sale: "I, Ebenezer Bucknam…do hereby give, grant, sell and convey unto the said William Micklefield a certain piece of land…through which runs the brook from Spot Pond with all the rights & privileges that I have of flowing the water above where the snuff mill now stands on said land built by the said Micklefield."

Unlike other mill owners on Spot Pond Brook at this time, Micklefield was not a native of New England. Born in Ipswich, England, in 1774, he had sailed to Boston with his father in 1794. Upon landing, he took a job as a tobacconist in Boston and married Sarah Bailey. But their life together was short-lived. Micklefield had just finished building his snuff mill on Spot Pond Brook when Sarah died, most likely in childbirth. Micklefield wasted no time

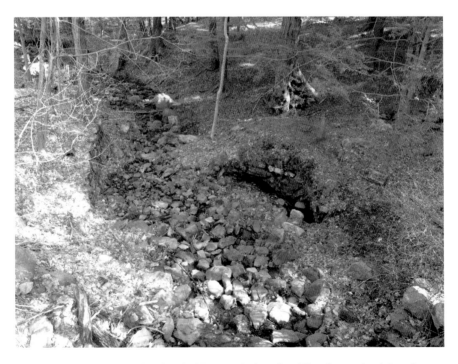

This hemispherical depression, lined with stone, in Spot Pond Brook contained the tub wheel that powered Micklefield's snuff mill and Hurd's factory from about 1798 to 1847. *Photo by Douglas Heath.*

finding another wife. Less than a year later, in February 1799, he married Hannah Hitchens, and they moved into a house near his new mill.

In April 1801, Micklefield sold half of his lot (one-quarter acre) to David Stanwood, a block and pump maker from Boston, for $550, making a good profit in just fourteen months. The sale included a "messuage" (an old English word for a house, yard and outbuildings), which was probably where Micklefield had been living with his wife and newborn son. The house site is shown on Perry's map of Haywardville (see page 15). As part of the sale, Stanwood also lent $500 to Micklefield. In return, Micklefield agreed to continue running the snuff mill and give Stanwood 25 percent of the annual profits.

Probate records show that by 1803, Micklefield was no longer running the snuff mill. He had moved to Marblehead with his family and was working as a tobacconist. Like many people in those days, he was later to lose his son in 1825 and his wife Hannah the following year. But, as before, he soon married again. He and his third wife, Sally Robinson, lived in Salem until 1840, when Micklefield died from "palpitation of the heart." In his will, he directed that his Salem mansion, mill machinery and other assets be sold, with the proceeds donated to the town of Marblehead.

Stanwood did not challenge Micklefield's decision to stop running the mill. Micklefield may have paid off his debt and simply moved on. In any case, the snuff mill did not last for many more years. In December 1809, Stanwood sold the land and house for $150 to James Hill, a local housewright, and his son, James Hill Jr. The deed granted the Hills "one half of all the rights and privileges of flowing the water where the snuff mill stood built by William Micklefield." Four years later, the Hills sold this, along with other nearby land parcels, to brothers Joseph, William and Thomas Hurd of Charlestown for $4,000. Joseph Hurd, a wool and cotton fabric merchant and an inventor, then built a mill on the site of Micklefield's mill. Over time, this became known as the "Hurd factory."

Chapter 5

Downstream Mills Revisited, 1798–1838

MEANWHILE, BACK IN MALDEN...

When mills were first appearing in the ravine, Samuel Tufts (owner of the former Coytmore mill site) found himself, like the Spragues before him, at the center of conflict over his rights to control flow in Spot Pond Brook. But this time, the problem was at his own Malden mills. Historically, alewives swam upstream from the Mystic and Malden Rivers, up Spot Pond Brook to Ell Pond. Although this route went past the Malden mill site, when it was owned by the Spragues, fish apparently were able to swim past the millpond dam. But Tufts must have heightened the dam or closed off a fish passage because, in February 1798, nine Malden residents sent a letter of complaint to magistrate Cotton Sprague. One of the signatories was Nathan Lynde, who had built Bucknam's dams and sawmill in the ravine. The letter stated that "it is well known that Samuell Tufts of Malden has for many years past obstructed the fish called alewives at his mill damm in said Malden contarary to the law of this commonwealth and to the grate damage of maney people." They asked Cotton Sprague to "sue Tufts for obstructing the fish passage" and promised to pay him "our Equal shear of all the cost and charge that you shall need to spend for conveying thence the said lawsuite."

Two years later, in February 1800, Stoneham farmer John Bucknam (cousin of Ebenezer Bucknam) sued Tufts for $100 for flooding twenty acres of his fields beside Spot Pond. Bucknam requested a jury trial at the Inferior

Court of Common Pleas in Concord, but to his surprise, the verdict was not in his favor. The court upheld Tufts's right to control the height of water at the dam and charged Bucknam $3.98 in court costs. The following month, Bucknam appealed the case to the Supreme Judicial Court in Cambridge. The second jury upheld the first jury's finding, saying that Tufts "has had and now has, a prescriptive right to keep up the dam in the same situation and height as in his plea he has declared," and added $76.37 to Bucknam's court costs.

Barrett's Dye House and Odiornes' Nail Factory

In March 1803, Tufts sold one acre of his Malden property, located several hundred feet downstream of his mills, for $800 to silk dyer William Barrett (no relation to James or Ebenezer Barrett). Born during the Battle of Bunker Hill in 1775, Barrett had previously worked at the Shattuck Company, dyers of silk and wool, in Charlestown, and wanted to start his own dye works. The deed granted Barrett "free use and benefit of the water as it runs in the brook" and the right to install a three-inch-wide aqueduct through Tufts's mill dam to convey water to his dye works. The deed also required Tufts to keep the water in the millpond at a height at least two feet above the bottom of the aqueduct except when water was low or for repairing the dam. Soon after opening "Barrett's Dye House," in February 1804, Barrett married Mary Keezer Hall from Medford. Over the next nineteen years, they had twelve children.

Tufts continued to sell land in Malden. In March 1805, he sold twelve acres "with all the buildings thereon" to George, Thomas and Ebenezer Odiorne, three brothers who owned a dry goods company in Boston, and Andrew Dexter Jr. The deed included "a right to a certain mill stream running from Spot Pond so-called with the waters of said pond & the dam together with all the privileges and appurtenances belonging to the premises (excepting… the land and privileges I have already sold to sd William Barrett)." The land that Tufts sold included the site of the original Coytmore corn mill, which meant that the new owners, the Odiorne brothers, now held the water rights to Spot Pond Brook (the Coytmore privilege). The following year, Dexter sold his quarter share of the property to George Odiorne.

The three brothers established the Malden Nail Factory just downstream of present-day Mountain Avenue and a short distance upstream from

Francis Alexander painted these portraits of William and Mary (Hall) Barrett in 1834 and 1833, respectively. Alexander was a prominent artist, whose portraits included that of Charles Dickens during the author's visit to Boston in 1842. *Porter-Phelps-Huntington House Museum, Hadley, Massachusetts.*

Barrett's Dye House. Their business was one of the first in the United States to patent and produce machine-cut nails. By 1810, they were operating twenty-two machines that cut and "headed" nails in one operation at the rate of one hundred per minute.

On February 8, 1816, disaster struck Barrett's Dye House. The dye house and Barrett's house, both built of wood, burned to the ground in a spectacular fire. No one was hurt, but losses were estimated at $30,000, with insurance only covering $5,000. But within three months, Barrett had built a new dye house and a house for his family.

Barrett's new "dye house" was actually several buildings, which were described in an 1828 insurance inventory, now housed at the Amherst College Library Archives. After his experience with fire, Barrett made sure that all these buildings had "a good pump affording a plentiful supply of water." One block of buildings contained about fourteen living quarters for workers and their families. It also contained coal rooms, counting rooms, a calendering room for rolling fabrics, one large hall containing a long lap frame for drying silks, three waterwheels, one fulling mill, a rasping machine (to strip bark off wood), one chipping saw, one sawmill and store

rooms for dye stuffs. The total value of this block of buildings was $32,200 in 1828 dollars.

There were two wooden buildings with millstones, a waterwheel, shops for carpenters and machinists, a dye shop and laboratory and a shoemaker's shop. The property also contained five houses for workers, including one occupied by Gilbert Haven, the factory manager and, later, executor of Barrett's estate. There was also a soap house for making soap and preparing dye stuffs, a barn and a building for storing sumac. Sumac tannins were used for dyes and in leather making.

The best-known building was a wooden building known as the "Red Mill," located downstream from the dye house. In 1828, at the height of its operations, this building contained a gristmill, a fulling mill, a pulverizing mill and a bolting machine. Just a decade later, it was used only for grinding grain.

Such a large dye works needed a steady supply of water, which was supplied from a large millpond owned by the Odiornes. During wet years, this pond extended one and a half miles to the Wyoming Hill railroad station in Melrose. This pond no longer exists.

When the Odiornes bought their land from Tufts, they were required by their deed to continue to allow Barrett "free use and benefit of the water as it runs in the brook." However, that was back in 1805, when Barrett's Dye House was a modest affair. For many years, flow from the Odiornes' millpond allowed Barrett to operate his dye house with little interruption. But as the dye and nail factories expanded, their water needs grew; inevitably, the Odiornes' control of flow from the millpond affected Barrett's Dye House.

Barrett avoided having legal battles with the Odiornes, but after his death in 1834 from tuberculosis, his widow, Mary, and five sons challenged the Odiornes' right to obstruct flow to the dye factory. In 1838, they wrote to George and Thomas Odiorne (Amherst College Archives):

We the undersigned being the owners of the Mills and Real Estate formerly owned by the late William Barrett Esquire of Malden think it proper to state to you the grievances and mischief which we suffer in relation to these mills, by reason of the obstruction, detention and irregular use by you of the waters which ought to run our mills in Malden and in Stoneham. We find that the water is sometimes detained and kept back altogether during the day time, when our mills need it, and cannot operate without it, and afterwards let down and permitted to run during the night and is thus wholly lost to us. At other times for many days and weeks, you have stopped and held

Etching of William Barrett's Dye House in Malden about 1817. *Malden Public Library.*

back the waters of Spot and Ell Ponds from us wholly, so that our works have been during such times, and unable to run. We therefore request you to permit all the waters above our mills and works, both those in Malden and in Stoneham, to run and flow to our mills, as they have been want to do in times past. And always until your gated and other obstructions were interposed to intercept and detain them.

George Odiorne replied brusquely:

Your communication dated September 27th 1838 is but just received. If you have ever read the deed of the premises purchased by your late husband of myself, Thomas Odiorne and Eben Odiorne situated in Malden, you have strangely misapprehended its contents, all that is conveyed by that deed you can justly claim, anything else is inadmissible.

GEORGE ODIORNE VERSUS THE CITY OF BOSTON

By the 1790s, it had become clear that Boston would need to tap water sources outside the city for it to continue to grow. Jamaica Pond, the main reservoir for Boston, lacked capacity and was becoming polluted, and fires regularly raged out of control because of inadequate water to combat them. By the 1830s, there was consensus in Boston to build a new water supply system. Daniel Treadwell was chosen to study the options, and he recommended pumping from the Charles River at Watertown. But others, notably Robert Eddy, a civil engineer working for the city, pushed to use Spot Pond and the Mystic Lakes. In 1836, Eddy wrote a report recommending that the city take Spot Pond. George Odiorne saw the threat immediately. If the city took Spot Pond, his mill in Malden would be cut off from its source of water. Indeed, none of the mills on Spot Pond Brook would survive this taking. Court records include a letter from Odiorne to Eddy asserting his claim to the waters of Spot Pond. He argued that because he owned the land that originally belonged to Thomas Coytmore, he owned all of the water rights granted to Coytmore by the General Court of Massachusetts in 1640:

> *Said grant was for 500 acres; to include the great swamp and pond lying in Charlestown. The same year, Thomas Coitmore, the grantee, erected a temporary dam across the outlet, by which he raised the water to the height of nine feet about its usual level, and built a corn-mill upon the stream. Very soon after this, Mr. Coitmore died and his widow inherited the estate. During her widowhood the dam became leaky, and by the consequent waste of water, many acres around the pond were laid bare, and soon yielded large crops of hay. In 1650, the widow married John Coggin, who repaired the dam and restored the water to its former height. The Abutters, being displeased with the loss of what they called "their meadows," commenced suits at law for the recovery of them, but were defeated. They then committed various trespasses, by obstructing the stream issuing from the pond, and by making breaches in the dam to the injury of the mill owners, and for their trespasses had to pay damages. They then petitioned the Governor and Council for redress…and the examination resulted in establishing what should be considered as the high water mark. A hole was accordingly drilled in a permanent rock near the water's edge, and at the height agreed on, which hole has been for more than a hundred years a standing umpire between the parties.*

The controversy over Boston's water system continued into the 1840s. The city sought the opinion of prominent civil engineer Loammi Baldwin Jr. He recommended using Long Pond in Natick. Finally, Boston officials turned to John Jervis of New York, the nation's leading water supply engineer, who was chief engineer of the Erie Canal. Jervis concurred with Baldwin and, in 1845, work began on Long Pond (now Lake Cochituate). And so the mill community along Spot Pond Brook was granted a reprieve, but the trends all around it—growing demand for water supplies, replacement of water with steam power and the rise of large factories— did not bode well for its long-term future.

Chapter 6

Back in the Ravine

Satinets, Sashes and Brass, 1804–1869

THE INDUSTRIAL REVOLUTION ARRIVES

While William Barrett and the Odiorne brothers were starting their dye works and nail factory downstream in Malden, the mills in the ravine in Stoneham had been changing hands rapidly. They also were producing a wider range of products, reflecting technological advances and a growing demand for goods in the larger world. This was the start of the nineteenth century, and the Industrial Revolution was changing patterns of people's lives. Barrett's mills in Malden and Stoneham were part of the revolution in the textile industry, which had begun in 1793 with Samuel Slater's first water-powered textile factory in Pawtucket, Rhode Island. Every other industry was rapidly changing, as production of goods moved from home businesses to machine-aided production in factories. During this period, Stoneham was transformed from a rural farming community into a small manufacturing center recognized for its leather and shoemaking industries. By the 1830s, Stoneham's reputation for producing shoes had earned it the nickname "Shoe Town."

JOSEPH HURD

At the start of the nineteenth century Micklefield had stopped running his snuff mill at the head of the ravine. Joseph Hurd now owned the land and arrived with ideas for producing new products. In 1814, he built a new mill on the stone foundations of the old snuff mill. Based on an 1846 map by Charles Whitney, Hurd's mill spanned 120 feet across the brook. Whitney surveyed the brook using a simple transit and measured the width of Hurd's mill using a set of links and chains. The mill foundations are still visible today.

Hurd's mill was two stories, with the first floor containing the woodworking machinery and the second floor containing rooms for workers and their families. Hurd lived on a nearby farm on the eastern shore of Spot Pond. His mill, locally known as the "Hurd factory," was probably powered by a fourteen-foot-diameter tub wheel like that used previously by Micklefield. The factory produced wood products, chimney ventilators and a type of fabric called satinets, which was an

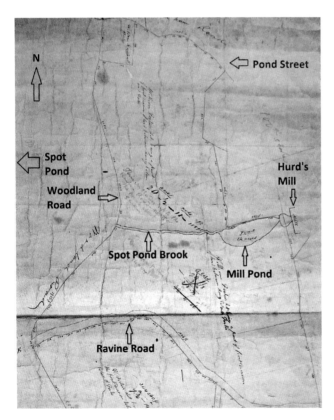

Detail of Charles Whitney's 1846 survey showing Joseph Hurd's factory and millpond on Spot Pond Brook in Stoneham. *New England Historical Genealogical Society.*

imitation satin woven in silk or silk and cotton. Satinets were mainly used for furniture coverings and women's nightgowns. Hurd was familiar with satinets because he and his brother, William, had imported these, along with cashmere products, from England a decade earlier.

Hurd was a talented inventor and displayed many of his inventions at his factory for local residents to see. A description of these was included in Abner Forbes's 1852 *The Rich Men of Massachusetts*:

> At one time [Hurd] *was in the retail dry-goods line, then an importer, and finally went to France as agent of importers here, and remained there some years. Returned in ill health, and located himself in a romantic spot in Stoneham. His leisure hours are amused with a talent for inventions, chiefly in the way of cooking-stoves, of which he has produced quite a number, by no means deficient in ingenuity and utility. For these he takes no patent; nor does he put them into the market; but these, with his other inventions, stand arranged in his best rooms, as curious ornaments, for the view of visitors—and they are worth examining. First you find one that would boil a gallon of water with so many ounces of charcoal, in so many minutes. Next is one of another order; and so on to the last grand triumph, in the shape of a stove to cook on a large scale, without any fire whatever! The secret of this wonder, is a large concave mirror, some six or eight feet in diameter, arranged by clock-work to concentrate the sun's rays upon the food, &c. The mirror will fire a plank at several rods distance, instantly; nevertheless, in a three-weeks storm, a family dependent upon this ingenuity might chance to go hungry; although there are parts of the world where it might be eminently useful. He is likewise an agriculturalist, making many curious experiments in that art; an extensive raiser of sheep, &c. Mr. Hurd possesses a generous flow of spirits, is gentlemanly, affable, and agreeable, in spite of his somewhat eccentric and solitary turn of mind.*

John Bryant, who had lived beside Spot Pond in the 1820s, described Hurd in a court document from 1904:

> *Well, when I was there, he was a man that went into all kinds of things.... He went into making satinets; I saw then in the mill some that he had made, and he had it on—he had a drying machine about 10 feet in diameter and made octagon; and there were bars set up, and then webs were hitched on, and that was revolved to dry it. Those things I recollect very plain.*

Hurd stopped using the mill between 1846 and 1852. It was probably torn down by 1852 because tax records from 1852 to 1857, the year Hurd died at age seventy-eight, do not mention a mill. Hurd's estate, valued at $48,000, included stock, his house and eight acres of woodland in Stoneham. A list of his possessions included "Chambers Dictionary (5 volumes), Dictionaire Historique (7 volumes), Dramatic works of Corneille (12 volumes), Hill on construction of Timber, Miscellaneous books, pamphlets & papers, 3 Guns, One box of patterns and castings, and a Miscellaneous assortment of stoves & machinery."

Hurd had never married and had no children. In his will, Hurd left $20,000 to the states of Maine, New Hampshire, Vermont and Massachusetts for research to improve maple sugar harvesting, one of his key interests. But his seven brothers and sisters were outraged and contested the will. The court eventually found in their favor, voided the will and divided the estate equally among the siblings. In May 1859, they sold the former factory property and other land parcels to Nathaniel Hayward for $6,000. Remains of Hurd's factory still exist, including a sluiceway, a dam, stone foundations and a stone-lined depression in the brook for the tub wheel.

JABEZ KENDALL

In June 1804, Edward Rumney sold his three-quarter share of the sawmill on Spot Pond Brook (formerly belonging to Bucknam; see page 52) to Jabez Kendall, a wheelwright from Charlestown, and Stephen Cutter (who already owned a quarter share) for $50. The following year, Kendall and Cutter bought a quarter-acre nearby from Bucknam for $45 and built a house and stable, as shown in Perry's 1860 map of Haywardville (see page 15). Although the two men now jointly owned the sawmill in the ravine, they had a stormy relationship. They frequently argued, especially over unpaid debts. In 1809, Kendall sued Cutter and asked the local constable to throw Cutter in jail if he failed to pay what he owed. The Court of Common Pleas in Concord ordered Cutter to give his land, which was appraised at $256, to Kendall. Cutter retained only a small strip of land along the road, as well as part ownership of the house he had shared with Kendall.

Kendall operated the sawmill for the next three decades, until 1837. Census records of 1810, 1820 and 1830 show that he lived in the house just north of the old Stoneham to Malden road with a woman about his age,

but her name is not given. It wasn't until 1860 that census records gave the names of men's wives and children.

Kendall's main products were wagon wheels, wooden sashes, blinds and boxes. He worked in the ravine so long that local people referred to his right to draw water from the brook as the "Kendall privilege." In 1904 court testimony, John Bryant, who grew up next to Spot Pond in the 1820s, described Kendall as "an old gentleman when I was a boy, and he used to do wood work….I think he used to repair some carriages. It was hard wood a good deal in those days…he worked on almost anything."

In June 1837, Kendall sold the sawmill, house and stable for $1,000 to another woodworker named Abel Baldwin. After the sale, Kendall moved to Somerville, near Boston.

Abel Baldwin

Abel Baldwin was born in 1799 in Fitchburg in central Massachusetts. He married Betsey Farwell in 1825 and moved to Boston, where they had three children: Caroline, who died at age two; Henry Jackson; and Otis Lincoln. After buying Kendall's sawmill, the Baldwins moved into a house on the mill property. At the mill, Baldwin used lathes and saws to make wooden products such as hubs for wagon wheels and legs for furniture.

During a 1904 court hearing to compensate landowners for the taking of Spot Pond by Boston for a reservoir, Sumner Bucknam, grandson of Ebenezer Bucknam (see page 49), testified that "Kendall ran it [the mill] as a wheelwright and turner, and he sold out to Baldwin, and Baldwin carried on the business of knobs for furniture." In 1842, Baldwin petitioned the Stoneham selectmen for funds to improve a "waterfall road" next to his property. However, it is not known whether he got these funds. Two years later, he mortgaged his property to his brother-in-law, Elijah Farwell of Fitchburg, for $500. In February 1845, Baldwin died of "dropsical consumption" (kidney and lung disease), leaving his wife, Betsey, to care for their young sons, Henry and Otis.

Because there was no will, Probate Judge Samuel Fay in Cambridge appointed family friends Peter Hays, John Brown and Daniel Perkins to make an inventory of Baldwin's estate. The document lists Baldwin's household furnishings, livestock and woodworking tools, with an appraised value of $440.79.

An Inventory of the Estate of Abel Baldwin, yeoman, late of the Town of Stoneham in the County of Middlesex, deceased, intestate, Appraised upon Oath by us the Subscribers, duly Appointed to that service by the Honourable Judge of Probate for the County of Middlesex, Viz. —

	$	Cts
Real Estate. —		
The Homestead of said deceased, situate in said Stoneham Containing about two Acres and three eights of land with the Buildings thereon, and the privileges thereunto belonging, Appraised at —	2000	00
Personal Estate.		
One Horse at $37 — an Old Chaise $10. — — —	47	00
Some horsechains and two har nesses $10. An hay rack $12.	22	00
Two Buffalo skins $2. — A Buggy waggon $14. —	16	00
One Horse Cart $35 — A waggon body $3. —	38	00
A pung sleigh $6. — An Horse sled $5.50. — A Dragg $1. —	12	50
A riding Saddle $3. — A wheelbarrow $2. — an Harrow $2. —	07	00
One plough $3 — Two narrow axes $1. — A Rake & hayforks $1. —	05	00
A wood saw $1. — A lot of hoes $2. — Two iron bars $1.25. —	04	25
A lot of much Shovels & forks $2.12 — A beetle & wedges 50 Cts —	02	62
A Stone hammer & pick axe $1.50 — A set of wooden measures 40 Cts. —	01	90
Two Scythes, Snaths, 75 Cts. A lot of boards $5. — One Hog $7. —	12	75
Four turning Lathes $95. — One Old Lathe $3 — Shafts & Drums $10. —	108	00
Four Circular saws & Apparatus $11. — A lot of turning tools $4.50 —	15	50
A Machine to bore Hubs, with the augers $15 — Four polishing Lathes $4.	19	00
A small Circular saw & stand $4 — Belts to drive machinery $5. —	09	00
A lot of whetstones $1.25 — A Cylinder stove & funnel $2. —	03	25
A Bit stock bits and files $2. — One Cross cut saw $5. —	07	00
Three hand saws $1 — A lot of augers $2 — A lot of planes $2.25. —	05	25
Shave, Squares, adz & wrench $2.50 — One Grindstone $1.50 —	04	00
Shop hatchets & hammers $1.50 — A lot of Mahogony $5. —	06	50
One Feather bed, bolster & pillows, Under bed, bedstead & Bedding —	10	00
One Feather bed, bolster & pillows, Under bed, bedstead & Bedding —	05	00
One Feather bed, bolster & pillows, Under bed, bedstead & Bedding —	05	00
One Feather bed $2.50. — Four Coverlets $3. — —	05	50
Nine Cotton Sheets $2. — Ten pillow cases, 50 Cts. Four window curtains 50 Cts —	03	00
A Carpet $5. — A Secretary $6. One Table $3. A waiter 50 Cts —	14	50
Two Chests $2.50. — A set of draws & small desk $2. —	04	50
	$394	02

First two pages of Abel Baldwin's estate inventory, made after his death in 1845. *Massachusetts Archives.*

the Hon S.P.P. Fay, judge of Probate.... in and for the co. of Middlesex, on Thursday, 9th of April next, at 10 o'clk a m on the premises, so much of the real estate of Abel Baldwin, late of Stoneham, in said county, turner, deceased, intestate, as will raise the sum of two thousand six hundred dollars and 42 cents, for the payment of his just debts.

The premises are situated in Stoneham, near the farm house of Jos Hurd, jr by Spot Pond, and contains about 3 acres more or less. On the premises is a good two-story house, good barn and a shop calculated for any kind of mechanical purposes, with a most excellent water privilege. The land is under a state of good cultivation, with valuable fruit trees on the same, about 30 apple trees newly grafted. The above will be sold subject to two mortgages, on which there is now about $1400. Conditions at the time and place of sale.

Also after the above, the personal property of the deceased, consisting of 4 lathes, belting, circular saws, tools and household furniture. *Betsey F Baldwin*, Admx.
 Saml Blanchard, Auct.
Stoneham, Feb 19, 1846.

A February 1846 newspaper notice announcing a public auction to sell Abel Baldwin's property. *Massachusetts Archives.*

Abel Baldwin's real estate, "containing about two acres and three eights of land with the Buildings thereon and the privileges thereunto belonging," was assessed at $2,000. However, he left Betsey with nearly $3,000 in unpaid mortgages and other debts that he owed to as many as thirty-five people. In January 1846, she claimed insolvency and asked the court's permission to hold a public auction in hopes of raising enough money "for the payment of his just debts." On April 9, 1846, auctioneer Samuel Blanchard of Medford held the auction at her house, selling Baldwin's sawmill, house, barn, thirty "newly grafted" apple trees and personal property to Cyrus Brown of Tewksbury. However, he only paid $700, which was not enough for Betsey to pay all her husband's debts.

By 1850, Betsey Baldwin's sons, Henry and Otis, were living in Boston and working as "brass founders." Their mother was also living in Boston, but with her stepbrother, merchant Abel Farwell. In 1860, Henry was still living in Boston but working as a turner like his father. Otis had moved to Lynn with his mother and also worked as a wood turner.

On December 27, 1870, Betsey Baldwin had a stroke at her home in Lynn, leaving her paralyzed and unable to speak. She died three days later. At her funeral, Otis produced a will that was dated December 30 and supposedly signed by Betsey the same day of her death. Henry was enraged because it showed that he was to receive less of his mother's estate than his brother. He suspected that Otis had forged her signature, as Betsey was unable to move or communicate after her stroke, and he decided to contest the will. In the probate records of Essex County, there are seventy pages of affidavits and depositions relating to this case. The court voided the will and divided Betsey Baldwin's assets between the brothers, each of whom received $12,000.

CYRUS BROWN AND JOHN DAMON

When Cyrus Brown bought Abel Baldwin's property in 1846 from his widow, Betsey Baldwin, he paid her an additional $100 to give up her right to the estate. He moved into Baldwin's house with his wife, Eliza, and son, Joseph. Brown kept the house, barn, apple orchard and sawmill for five years before selling it in April 1851 for $1,550 to David Damon of Northampton, Massachusetts. Just seven months later, at age forty-nine, Brown died in Tewksbury from dysentery.

David Damon owned the mill property, but his younger brother, John, moved there and paid the taxes for the house, barn and other buildings. He was also taxed for four horses, a cow and a carriage. John Damon lived with his wife, Eliza, and their four children, ranging in age from twenty-one to eleven, in the house behind the sawmill. He worked as a cabinet maker in the carpentry shop, which was powered by the mill's large overshot wheel.

As his furniture business expanded, John Damon built an addition to his mill and hired six or seven men to help make furniture and boxes. Among Damon's workers were James Mooney and Levi Flanders. When Mooney started working at the mill, he was twenty years old and had just arrived from Nova Scotia on the brig *Brilliant*. Flanders, a native of New Hampshire, worked at the mill until 1854. The following year, he moved to nearby Wakefield, where he joined many of the town's men and boys in harvesting and selling ice from Lake Quannapowitt.

Damon's sawmill could only operate if there was sufficient flow in Spot Pond Brook to turn the waterwheel, and this flow was controlled by the gate at the Spot Pond dam. As had been true since 1640, only an owner of the former Coytmore mill site in Malden could legally open or close the gate. This mill site now belonged to Charles Parsons and David Dyer, who had bought the Odiornes' nail factory (see page 57) and converted it into a flour mill in the late 1840s. However, because Damon's mill was near the gate, he was able to convince Parsons and Dyer to pay him to raise or lower it as needed. Damon testified in court in 1873 that "he hoisted and closed it as they requested; that while he was there he never knew anybody to have control over the gate except himself, Mr. Parsons and Mr. Dyer, and when he was not had to stand still; that sometimes he got water on leave by applying to Mr. Parsons; that when they let down the water, it came by his mill."

THE GRUNDY BRASS FOUNDRY (1854–1869)

In July 1854, David Damon sold the sawmill, house and barn to Willard Snow of Paxton, Massachusetts, for $4,000, more than twice what he had paid in 1851. Just three weeks later, Snow sold the sawmill property plus a small land parcel north of the old Stoneham–Malden Road to James, Thomas and Joseph Grundy.

The three Grundy brothers were born between 1813 and 1821 in Birmingham, England, long known for its fine metalworking. While still living in Birmingham, they all married local women and started families. James, the oldest brother, married Elizabeth Clarke in 1836, and by 1845, they had five children. Thomas, the middle brother, married Eliza Wilkinson in 1840 and, in 1844, had a child. Joseph, the youngest brother, married Jane Chamberlain, and they also had a child in 1844.

Although they all had young children, the three brothers decided to make the sea voyage to America to pursue new opportunities. In July 1844, Thomas and Joseph Grundy and their young families sailed in steerage from London to New York on the *Montreal*. A year later, James Grundy and his family sailed, also in steerage, from Liverpool to New York on the ship *Hottinguer*, arriving in June 1845. The *Hottinguer* was to sink in a storm off the Irish coast five years later.

Once reunited, the three families moved to Roxbury, a part of Boston, and established a business on Cabot Street called J. Grundy and Brothers Brass Founders of Boston. For the next nine years, the brothers worked together while their families continued to grow. In June 1852, James Grundy's wife, Elizabeth, died while giving birth to their eighth child.

By 1853, the brothers had decided to set up their own factory and began to look for a good mill location. They heard about the sawmill that Willard Snow had just purchased on Spot Pond Brook. With a large overshot wheel in a deep ravine, this mill appeared powerful and large enough for manufacturing metal products. Also, it was located less than a mile from the Boston and Maine Railroad's Wyoming Station, providing easy access to Boston, Malden and other markets. They approached Snow in 1854 and bought the mill for $4,000.

Thomas stayed in Roxbury to run the company's Boston office, while James and Joseph Grundy moved with their families to Melrose, near the mill. The two brothers replaced Damon's wooden addition to the sawmill with a brick foundry for producing brass plumbing fixtures and machine parts. The mill's large overshot wheel powered the bellows for the furnace.

By 1855, the Grundy foundry had hired fifteen brass finishers from England, Ireland, Massachusetts and New Jersey, ranging in age from fifteen to forty. Before long, the foundry was annually producing about $25,000 worth of brass items and, in the process, consuming about 10,000 pounds of copper, 2,500 pounds of zinc, 7,000 pounds of lead and 150,000 pounds of iron. Meanwhile, James Grundy, who had been a widower since 1852, married Sarah Gaskins, an immigrant from England. They had two children, born in 1856 and 1860. With these, James now had ten children, with more than twenty years separating the oldest from the youngest. Unfortunately, in 1861, his sixth child, Anna, died in Stoneham at age fifteen of typhoid fever. Joseph Grundy, who lived near his brother James in Melrose, arrived in Massachusetts with one child but went on to have nine more children.

The Grundy foundry was an extended family affair. Some of the Grundys' sons became workers at the mill, as did other relatives from Birmingham, England. These relatives included Isaac Wilkinson, Charles Raybould and Edward Scrannage. Wilkinson was the brother of Thomas Grundy's wife, Eliza. In 1848, three years after his sister had settled in Roxbury, Wilkinson, still a teenager, set sail to join her. Raybould and Scrannage were married to sisters of the Grundy brothers, Caroline and Hannah. Raybould sailed with his family from Liverpool to Boston on the *Curling* in August 1858. Two years later, they were living in a house in Melrose, and Raybould and two of his four children, Benjamin and William, were working at the brass foundry. Several years later, the Raybould family converted to Mormonism and traveled two thousand miles on a wagon train to Salt Lake City.

Scrannage arrived in Boston in 1857 with his wife, Hannah, and four children and bought a house lot for $250 on Wyoming Avenue in Stoneham, a short distance from the foundry. This lot is visible on the right side of G.M. Hopkins's 1874 map of Stoneham (on page 15), just west of the Randall property. In 1860, Edward Scrannage worked in the foundry with his two sons, William and Matthew. A third son, Edward Scrannage Jr., joined them when he turned seventeen.

The foundry operation depended on a steady flow of water from Spot Pond into Spot Pond Brook. In 1864, the Grundys installed a ten-horsepower steam engine, powered by coal, for added power when flow in the brook was low. However, they preferred using free water power as much as possible. Like mill owners on Spot Pond Brook before them, they sometimes resorted to illegal means of increasing flow through the dam. At a 1904 court hearing, Charles Elder, attorney for the city of Malden, asked James Grundy Jr. whether his father had ever interfered with the flow from Spot Pond dam:

Elder: Do you know of anyone boring into the dam at night for the purpose of getting a flow of water?

Grundy: Yes, sir.

Elder: When the gates were closed?

Grundy: When the gates were closed.

Elder: Who did it?

Grundy: Well, men that were employed by my father; we had no water, and we wanted some to run the factory.

Elder: What sort of a bore did they use?

Grundy: About an inch and a half bit, an old fashioned boring bit, one with a cross handle.

Elder: Did your father put in any other power than the water power there?

Grundy: Yes sir; he had to put in an engine.

Elder: How large an engine, what capacity, do you remember?

Grundy: I should think it was about 10 horse-power.

Elder: Why was the engine put in, if you know?

Grundy: Because we couldn't get water enough to drive the works.

Elder: I think I asked you whether or not the regular flow of the brook would have been sufficient for your business?

Grundy: The regular flow would have been, if they hadn't tampered with the gates up there.

Elder: What do you mean by "tampered with the gates"?

Grundy: Come up there and closed it when they wanted to.

Elder: Was it a matter of common knowledge in the community that the Dyers controlled that gate?

Grundy: Yes, sir.

A decade later, after the Grundy foundry had stopped operating, the three Scrannage brothers started their own metalworks in Boston called Scrannage Brothers & Cook. In 1883, their father, Edward Scrannage, died at age sixty-six of "chronic rheumatism" and was buried at Melrose's Wyoming Cemetery. He had a modest estate—his most valuable possession was a gold pocket watch worth seventy-five dollars. He also had a "box of old books, a copy of *Websters' Dictionary* and a two-volume set of *Circle of Sciences*," showing that he was literate at a time when many of his fellow workers were not.

James Grundy died in 1863, followed by his brother Thomas in 1865, leaving Joseph Grundy to run the business on his own. But the best days of the brass business were over. In 1869, a probate court judge ordered that a

public auction be held to sell the foundry and other property to raise money to support James's and Thomas's children. That July, a notice appeared in Boston's *Daily Evening Traveller*:

Guardian Sale of Real Estate—in Stoneham and Melrose—

By virtue of several licenses of the Probate Court for the County of Middlesex, will be sold, at Public Auction, on the premises first hereinafter described, to wit: At the Brass Foundry in Stoneham, in said county, on Sunday the 19th day of July, 1869, at 4 o'clock in the afternoon—

All the right title and interest of the several Minors hereinafter named, to wit: Thomas George Grundy, Edward Thomas Grundy, Thomas Benjamin Grundy, Rebecca Jane Grundy, Minors, in the several parcels of real estate hereinafter described—1st. An Estate with the buildings thereon situated in Stoneham and known as the Grundy Mill and Foundry with the factory buildings, tenement houses, dam and water privilege, being the premises conveyed by deed of Willard Snow to James Grundy and others dated July 14, 1854 recorded with Middlesex So. District Deeds Lib. 686, folio 561.

Theodore Weeks (see page 86) bought the brass foundry and land for $5,000, and Joseph Grundy gave $4,000 of this sale price to the guardians of his brothers' children. Under Weeks's ownership, the foundry continued to run for a few years with help from three of the Grundy sons—James Jr., Edward and William. According to the 1870 census, the foundry still had sixteen workers. Twelve of these were immigrants from England, including the Grundy sons and Edward Scrannage and his sons Edward Jr. and William.

In the early 1870s, James Grundy Jr. opened another foundry in Boston that ran on steam power. In 1885, a business directory called *Leading Manufactures and Merchants of the City of Boston: And a Review of the Prominent Exchanges* described this brass works:

James Grundy & Co Brass Founders and Finishers No 7 Province Court—One of the oldest and best known brass foundries in this city is that of Messrs James Grundy & Co of No. 7 Province Court. The business was originally established in 1845 on Cabot Street under the firm style of Grundy Bros. Subsequently, this style was changed to Grundy & Co and in 1881 the present sole proprietor Mr. James Grundy succeeded to the business and removed it to its present location at No. 7 Province court. Here

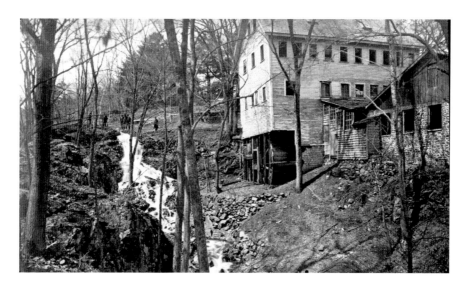

Ebenezer Bucknam's sawmill, photographed by George E. Davenport in about 1885. The brick-walled Grundy Foundry is visible at right. *Medford Historical Society & Museum.*

> *they occupy a five story brick building the workshop being 25 x 70 feet in area. A force of ten workmen are employed and the firm executes all kinds of brass and experimental work and control several inventions which they manufacture. Mr. James Grundy is a native of England, a member of the order of Odd Fellows, and a thorough practical man of business.*

After 1870, the sawmill and foundry buildings fell into disuse or were used for storage. For example, while the family of Charles Jones lived in Ebenezer Bucknam's old house in the 1880s, his wife, Mary, used the abandoned brass foundry to house her chickens. An 1885 photograph by photographer George Davenport shows that the sawmill and foundry were not operating. Both were still standing, but there was no flume to convey water from the mill dam to the overshot wheel. Instead, water flowed freely from the dam into the ravine. The brick foundry is visible at the far right with at least three windows missing glass panes.

Chapter 7

The Stoneham Factory

Dyes to Rubber, 1813–1858

Back in 1813, when Joseph Hurd was about to build his "Hurd factory" on the foundations of Micklefield's snuff mill and Jabez Kendall was running his sawmill a short distance downstream, the lower ravine was a woodlot. It was an ideal location for another mill, and that did not go unnoticed for long.

WILLIAM BARRETT

By 1813, William Barrett's Dye House downstream in Malden was a success. However, Barrett saw an opportunity to expand his business by processing his own dyestuffs rather than buying them from local merchants. He had heard about Kendall's sawmill upstream in the Spot Pond Brook ravine (see page 66) and that water power there was impressive. Scouting the area, he identified an ideal parcel of land, an eight-acre woodlot near the bottom of the ravine bordering the Stoneham–Malden highway. Ownership of this land dated back to the Barrett family (no relation to William Barrett) in the seventeenth century. The original owner, James Barrett, had left the land to his son, Ebenezer, who in turn had given it to his son, Joseph. The wills of Ebenezer, a cordwainer (shoemaker), and his son show that they were well off, owning more than forty acres of land and several buildings in the area. Joseph died in 1800 and left the eight-acre woodlot to his wife, Martha, and his daughters, Betsey, Nancy and Mary.

William Barrett approached Martha and offered to buy the woodlot. They agreed on a price of $116. The September 1813 deed included a provision that allowed Martha's family "free access to said wood lot at all seasons of the year and of cutting and carrying away said wood for the term of ten years."

For his new dye mill, which became known as the "Stoneham factory," William Barrett needed a millpond that would provide water when flow was low in Spot Pond Brook. Such a pond would require a large dam. In 1814, Barrett hired the man considered to be the best local mason, Nathan Robinson, to build a dam of rock and earth across Spot Pond Brook. The completed dam was more than 245 feet long and still stands today.

While the dam was being built, Barrett began building his dye mill and a house and barn on the property. He hired Oliver Wheeler, a local miller, to operate the mill. Wheeler lived with his wife, Harriet, and three children in the new house.

As well as processing dyes for Barrett's Dye House in Malden, the Stoneham factory ground arsenic, herbs and barberry root, which were used in medicines at that time. For example, barberry root was commonly used for treating sores, burns, ulcers, ringworm, cuts, bruises, gallstones, diabetes, bladder infections and tuberculosis (then called "consumption").

Excerpt from an 1828 inventory of William Barrett's dye works describing the "Red Mill" in Malden and the factory, dwelling house and barn in Stoneham. *Amherst College Archives and Special Collections.*

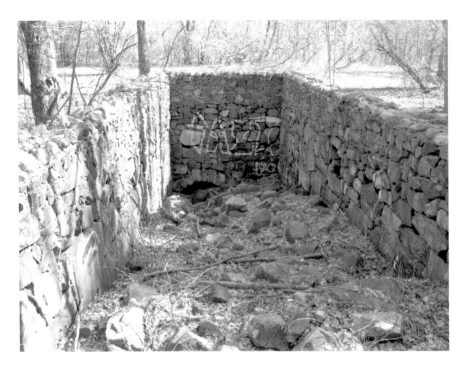

The wheelpit for the forty-foot-diameter breast wheel that powered the Haywardville Rubber Company in Stoneham. *Photo by Douglas Heath.*

Joseph Robinson, Nathan Robinson's son, described operations at Barrett's Stoneham factory in the 1904 court case as "grinding and chipping and so forth, cutting up dye woods to make dye stuffs of, and grinding anything that came along, chemicals and some grain—not much grain, but they did more pulverizing; had a pulverizing mill there where they could pulverize stuff up very finely both for dyeing purposes and for chemical purposes."

According to an 1828 inventory, the Stoneham factory was a wooden building containing a gristmill, fulling mill, pulverizing mill, bolting mill, rasping machine and grindstones. The property also had one wooden dwelling house occupied by the miller Oliver Wheeler, as well as a barn.

Ebenezer Bucknam's grandson, Sumner, described the factory in the 1830s: "The mills had an 18-foot wheel there, and afterwards it was enlarged: they dug out the stream and made a 40-foot wheel of it. They dug out the stream so that Odiorne's flowing wouldn't back water—Odiorne couldn't flow his pond high enough to back-water their wheel." The stone wheel pit for the forty-foot-diameter waterwheel still exists just below the Stoneham factory dam.

POLAND AND CONVERSE

James Converse, older brother of Elisha Converse, who owned property in Haywardville from 1846 to 1858 and helped to finance Elisha's factories. *Malden Public Library.*

Barrett ran the Stoneham factory until his death from tuberculosis in 1834. His wife and sons continued to run the factory until 1846, when they sold it to Elisha Converse of Roxbury and Benjamin Poland of Cambridge for $3,500. Two years earlier, these men had formed a company called Poland and Converse to manufacture drugs and spices. The Stoneham factory had the right grinding equipment and was an ideal location for their business.

The eight-acre Stoneham factory property included the factory, a house and buildings for processing dye products. To buy the property, Poland and Converse took out a $2,000 mortgage, with Elisha's brother, James, contributing the remaining $1,500. The new owners modified the mill to grind drugs and spices.

Elisha Converse took charge of the daily factory operations. In 1843, he had married Mary Edmands from Webster, Massachusetts, a marriage that was to last sixty years. The same year that he bought the factory, 1846, he and his wife had their first child, Francis "Frank" Converse, and they moved into the house beside the Stoneham factory. Shortly afterward, Converse's parents and Mary's younger brother, Thomas, moved in with them. (Frank was to have a tragic end. In 1863, at age seventeen, he was the first person killed by a bank robber in the United States.)

The Stoneham–Malden Road (now Pond Street), first laid out in 1722, was no more than a narrow, rutted dirt trail. By the mid-nineteenth century, it was woefully inadequate for travel of any sort. In 1846, local residents and businesses proposed to straighten and widen the road. To fund this project, they agreed to divide costs according to ability to pay. As the largest landowner, Poland and Converse contributed $970, or 61 percent of the costs. The remaining $620 was paid by Stoneham residents Ebenezer Bryant, Elbridge Gerry and James Gould. In June 1848, the Town of Stoneham reimbursed all parties. Today, an abandoned section of this road lies in the woods beside its modern replacement.

In 1849, Poland and Converse dissolved their partnership so that Poland could pursue other business interests in Boston. Converse then partnered with John Robson, a local businessman, and they renamed the company Converse and Robson, which still processed drugs and spices.

In 1850, the Converse family moved from Stoneham to Malden, mainly because Mary felt isolated and lonely while living at the Stoneham factory. In Malden, Converse became known for his involvement with civic affairs and helped found the First National Bank of Malden. When Malden became a city in 1882, Converse was elected as its first mayor.

Albion H. Bicknell painted this portrait in 1884 of Elisha and Mary Converse's son, Frank (1846–1863), who was shot and killed by Malden postmaster Edward Green in Malden on December 15, 1863. Frank was the first person killed by a bank robber in the United States. *Malden Public Library.*

Converse dissolved his partnership with John Robson in 1853 and became treasurer of a new company, called the Malden Manufacturing Company, for making rubber shoes. The company included most of the people involved in the American rubber industry at the time, most notably Nathaniel Hayward and Leverett Candee, both of whom owned large rubber factories in Connecticut. In 1853, the Malden Manufacturing Company bought a factory in Malden (not on Spot Pond Brook). They renamed the company the Boston Rubber Shoe Company. But Converse was not satisfied with just being treasurer of this company. He saw that there was money to be made in rubber products and devised a plan to also convert the Stoneham factory into a rubber factory.

In 1855, Converse partnered with his brother, James Converse, and his new friend Nathaniel Hayward and retooled the Stoneham factory to make rubber products, especially rubber boots.

Elisha and Mary (Edmands) Converse. *Malden Public Library.*

NATHANIEL HAYWARD

The Converse brothers could not have chosen a better partner in 1855 than Nathaniel Hayward to start a rubber business on Spot Pond Brook. Hayward had developed, with Charles Goodyear, vulcanization of rubber and knew more than almost anyone alive about the rubber business. This knowledge had come from working with rubber for more than twenty years.

Rubber, derived from trees in Central and South America, had long been used in tropical areas. In 1820, a sea captain brought a pair of rubber shoes to Boston from Ecuador. This spurred a brief boom in rubber products, such as carriage tops, raincoats and boots, until people realized that they did not hold up in the New England climate. The rubber was rock-hard in the winter and turned into a gummy, sticky mess in the summer. In 1834, Hayward did experiments on the rubber and found that he could make it more elastic and durable by treating it with sulfur.

In 1835, he joined the Eagle India Rubber Company of Boston, where his discovery was used in its rubber products. A year later, Hayward bought part of the company. In 1838, Charles Goodyear sent Hayward an order for thirty yards of rubber cloth and was so impressed that he bought Hayward's interest in the company; Hayward became his employee. The two men signed a contract stating that Hayward would apply for a patent for producing rubber cloth under Goodyear's name. In return, Goodyear would pay for the patent and give Hayward several thousand dollars. The following year, Goodyear was able to improve their products when he accidentally discovered how rubber could be made to withstand heat without becoming soft. He made this discovery when he put a piece of rubber cloth treated with sulfur on a hot cylinder stove.

In 1843, Leverett Candee, a rubber manufacturer, asked Hayward if he could make a shoe out of the "fire proof gum." If so, Candee would buy out Hayward's remaining business interests and hire him at a good wage. Hayward took up the challenge and soon produced a trial batch of shoes. Candee hired him and began producing shoes at his Connecticut factory, becoming the world's first large-scale manufacturer of rubber footwear.

By the next year, Hayward had decided to go into business for himself and, with Henry Burr, started a small rubber shoe factory in Lisbon, Connecticut. In 1847, he founded the Hayward Rubber Company and built a factory in Colchester, Connecticut, which was powered by steam. The company produced rubber shoes and boots, attracting nearly one thousand people to work in the factory and spurring considerable growth in the town. Within

Nathaniel Hayward, co-inventor with Charles Goodyear of vulcanization of rubber and the man for whom Haywardville was named. *Colchester Historical Society.*

a few years, the company's business extended to every part of the United States and to Great Britain.

In 1855, Hayward was on the board of directors of the Boston Rubber Shoe Company, which was manufacturing rubber shoes at the Malden factory, when Elisha Converse approached him with the idea of converting the Stoneham factory on Spot Pond Brook from the production of drugs and spices to the production of rubber products.

In October 1858, Elisha and James Converse sold Nathaniel Hayward the Stoneham factory property and other land in Stoneham for $18,000. As part of this sale, Elisha Converse gave Hayward a mortgage of $15,000. Hayward incorporated the factory into his existing rubber company, the N. Hayward Rubber Company.

Elisha Converse died in Malden in 1904. In 1912, the *Register of the Malden Historical Society* included this tribute to him:

> *At some future date a skilled historian will write the story—both history and tradition—of the Middlesex Fells. The material is already assembling in various ways. To the average visitor the Fells to-day speak only of the departing glory of a primeval forest; of attractive drives and fascinating by-paths; of the music of carolling birds; of vistas of shady road and wide prospects from sightly hilltops; of beauty still in the making. The casual traveller seeks the formerly pine-shaded Ravine road, sees the partly devastated Virginia Woods, perhaps is told the story of how they and the Fells were preserved for future generations to enjoy because of the public wrath provoked by the mistaken policy that stripped the landscape of most of its growth of trees and made of it a wilderness, and wanders to the point where the ancient dam and still picturesque cascades mark the site of the Old Red Mills, and easily votes this region the most attractive in the Fells. But not one in a thousand of these visitors will know that here in the Virginia Woods, by his management of the old Red Mills, Elisha Slade Converse, millionaire and philanthropist, the benefactor of Old Malden in so many ways—religious social educational and humanitarian—laid the foundation of the fortune which was to be used so wisely and graciously for the benefit of his fellows.*

Chapter 8

Haywardville, 1858–1870s

When Hayward began operating his rubber mill in Stoneham in 1858, he still used water power exclusively and depended on the flow in Spot Pond Brook. A man named David Dyer now owned the water rights to Spot Pond Brook (the Coytmore privilege). Dyer owned the former Malden Nail Factory, which was now a flour mill. Legally, only Dyer could raise or lower the gate at Spot Pond dam. Dyer gave this responsibility to one of his agents, Wilson Quint. But knowing that Quint could be bribed, Hayward often paid him a dollar to "hoist the gate half an inch."

Fortunately for Hayward, there was now an increasingly popular alternative to water power. In 1860, he installed eight steam engines, which ran on coal, in his factory. By this time, his rubber factory was working at full speed. According to the 1860 federal census of manufacturers, the factory had thirty men, who were paid about $33 a month, and eight women, who earned $15 a month. Each year, the factory was processing $5,000 worth of India rubber and was burning nine hundred tons of coal worth $1,500. Labor costs were $13,440 annually. However, the company's annual output in 1860 was only $14,000 worth of goods, so despite all the activity, the business does not appear to have been profitable.

In 1863, Hayward sold the Stoneham factory to the Rubber Sole Shoe Company of Stoneham for $43,000. By this time, the factory complex was known as Haywardville. Even though the Rubber Sole Shoe Company was never a big financial success, it was the core of a vibrant community with families and dozens of children attending their own school (see chapter 9).

In 1865, William Bailey, a manufacturer from Providence, Rhode Island, loaned the shoe company $75,000. In exchange, he would get title to the land and factory if the loan was not repaid with interest in one year. The shoe company failed to make the payment, and in December 1866, Bailey took possession of the factory. Despite the company's failure to pay the loan, tax assessments for the company show that it actually rose in value from $11,000 to $18,000 during its three-year operation.

Over the next two years, the factory changed hands at least three times before being bought for $50,000 by Nathaniel Hayward's son-in-law, Theodore Weeks.

THEODORE WEEKS

Theodore Weeks was born on Martha's Vineyard in March 1840. His father, Hiram Weeks, was a sea captain. Unlike many Vineyard sons who followed their fathers in a seafaring life, the Weeks family left the island when Theodore was a child and moved to Colchester, Connecticut. When Theodore was seventeen, a state representative recommended that he attend West Point. Instead, a year later, in 1858, he married Nathaniel Hayward's nineteen-year-old daughter, Louisa.

That year, Nathaniel Hayward had bought the Stoneham factory, which he renamed the N. Hayward Rubber Company, and encouraged his son-in-law to move to Massachusetts to manage

Theodore C. Weeks, who bought all of Haywardville's buildings in 1869. Weeks married Nathaniel Hayward's daughter, Louisa. *Colchester Historical Society.*

the factory. Weeks agreed to take the job but waited two years to move to Malden. By then, he and Louisa had an infant daughter, Louisa. The Civil War began in 1861, and Weeks found that the Union army was a ready market for his rubber products. In a document of approvals by the Massachusetts Master of Ordnance, Weeks is listed among hundreds of suppliers for the war effort. This document shows that in 1862, Weeks sold fifty-six rubber pails to the Union army for seventy-one dollars.

Louisa H. Weeks, daughter of Theodore and Louisa Weeks, shown in the summer of 1882. *Colchester Historical Society.*

In 1863, Hayward sold the Stoneham factory to the Rubber Sole Shoe Company, but Weeks continued to run it. Two years later, Hayward died in Colchester. By then, the Weekses had a second daughter, Carrie, and according to census records, they had three servants to help run their Malden household. In 1869, Weeks bought the rubber company for $50,000 and renamed it the Haywardville Rubber Company. It included the "buildings thereon, and the water wheel, the steam engines and main boilers, and the main shafting and gearing attached thereto."

Louisa Weeks, daughter of Nathaniel Hayward and wife of Theodore Weeks. *Colchester Historical Society.*

R.G. Dun & Company, which pioneered credit reporting, listed Weeks as an "India rubber manufacturer" and stated in April 1869 that "Weeks has the Lockman Rubber Co.'s works worth $150,000 for which he paid about $40,000, & is endeavoring to form a Stock Co. Was agent for the N. Hayward Co....is at present with George W. Warren of Boston....Is worth 10 to 12 [thousand]."

R.G. Dun stated its approval of Weeks:

> [S]ome monied parties have assisted him to buy the factory at Stoneham which is [thought] to be a good bargain....It is supposed he intends to manufacture mats, spittoons, etc. which if well managed will [probably] pay. Is smart active & stirring and would not be likely to borrow money unless he intended to pay. Is considered entitled to fair credit.

WORKERS AND FAMILIES OF HAYWARDVILLE

According to the 1870 census, forty-eight employees worked in the Haywardville rubber factory. Ranging in age from twelve to fifty-two, these workers were from nearby towns and New England states, as well as from Pennsylvania, Canada, England and Ireland. Many lived in the

tenement building on the north side of Pond Street, which was built to house factory workers. Census records list some of these Haywardville workers.

Frank Lariviere was a French Canadian carpenter with a wife named Rose and four daughters. He worked in the rubber factory from about 1870 to 1880. His daughter Mary worked there from age twelve to at least twenty-three.

James Lewis Craig was born in 1835 in Readville, Maine, and served Maine's third Light Artillery Battery during the Civil War before moving to Haywardville with his wife, Annie. Both worked in the Haywardville rubber factory in the 1870s. Craig died in Stoneham in 1899 at age sixty-six.

Andrew Hines was born in 1836 in County Clare, Ireland. At age seventeen, already trained as a shoemaker, he sailed to New York. Four years later, he married Ireland native Eliza Mullen in Malden and began work as a watchman at the Haywardville rubber factory. Ten years later, he was still working at the factory and living nearby with his wife and five children. In 1890, census records show Hines living on Elm Street near Stoneham's poor farm. He died in Stoneham in 1897 at age sixty-one of pulmonary disease.

Robert Henry Terry was born in Surrey, England, in 1839. By 1864, he had immigrated to America and married Mary Cassell, a native of Ireland. From about 1869 to 1875, Terry worked at the Haywardville rubber factory. In 1881, he died of typhoid at only forty-two.

Hervey Hartwell Murdock was born in 1838 in central Massachusetts and lived on the coast in Nahant. He served with the 112th Illinois Infantry during the Civil War but was charged with desertion in 1863 in Tennessee. He came home to Massachusetts, married a woman from New Hampshire and got a job as bookkeeper at Hayward's rubber factory.

Edwin Hayes was born in Vermont in 1839. His sister, Emily Hayes Hayward, married Nathaniel Hayward's nephew, Charles Henry Hayward. In 1860, he was living with his sister's family in Haywardville and working at the rubber factory. In 1868, he married Evelyn "Eva" Davis and continued working at the factory. In 1870, he and his wife moved to Malden, and Hayes took a job at Elisha Converse's Rubber Shoe factory, where he eventually became a foreman. In 1908, he died suddenly of a heart attack.

As elsewhere, Haywardville families were affected by poor sanitation and lack of understanding of how diseases were transmitted. There was no indoor plumbing, and people rarely bathed. A sewer system in

Stoneham was decades away from completion. People used chamber pots and privies and cesspools for waste. Many people kept animals, especially horses, for transportation. Some houses had dug wells, but most people got their drinking water from Spot Pond Brook. However, the brook was commonly contaminated by human and animal waste, especially when it rained. Census and death reports show repeated outbreaks of cholera, dysentery, tuberculosis, typhoid fever and influenza. In addition, infants and their mothers commonly died from complications of childbirth. In Haywardville, families like the Wymans were all too typical. John Wyman worked in the rubber factory, while Patience Wyman worked at home and raised their children. In 1870, two of their children, infant twins Claron and Nellie, contracted cholera and died a few weeks later. Five years later, Patience Wyman died after giving birth to a stillborn son.

Chapter 9

Haywardville's Little White School, 1851–1899

EARLY EDUCATION IN STONEHAM

In 1729, Stoneham residents voted to raise £9 for a school for "reding and rightin," and shortly thereafter, the first school was built near the town's first church. A master was in charge in the winter and a mistress in the summer. For girls, training in household arts was considered essential, and writing was considered unnecessary. According to a 1938 report to the Stoneham Historical Society, even some of the female teachers could not write. This is shown by a salary receipt for a teacher, Joanna Burdett, who signed her name with a mark.

The first schoolhouses were small and uncomfortable, with no blackboards or maps, although some had globes. Students had no lead pencils until the nineteenth century, and lines in copybooks were ruled with lead plummets. Arithmetic problems were dictated by the teacher and probably done using quill pens dipped in ink. In 1789, a law was passed that required the teaching of arithmetic, the English language, orthography (spelling and punctuation) and decent behavior.

There were no standards in spelling until Noah Webster's first spelling books appeared in 1825. The first book from which children learned to read was called the hornbook, which was a slab of wood about two by five inches in size. A sheet of paper was attached to this with the alphabet in large and small letters, a row of simple syllables like "as," "ed," "or" and so

on, as well as the Lord's Prayer. The hornbook usually had a small handle with a hole so it could be carried by a string hung around the neck. The *New England Primer* succeeded the hornbook and was the country's main school book for at least one hundred years.

In 1793, Stoneham replaced its first school with a school just north of the town's meetinghouse. Thirty-three years later, the town built a building large enough to house all the town's schoolchildren except the youngest. The second floor was used for the town hall. In 1833, this building was moved by putting it on runners and using forty to fifty yoke of oxen to drag it to a site near the new Andover–Medford highway (now Main Street or Route 28).

In 1834, Massachusetts established the State School Fund and, three years later, the State Board of Education. The secretary of the board, educational reformer Horace Mann, promoted universal public education, leading to the system of public, graded schools.

WYOMING SCHOOL

In the late 1830s, Stoneham identified six school districts for younger students. One of these, District Four, was on the east shore of Spot Pond. This was to become the school for the children of Haywardville. However, it was more than a decade before money for land and a schoolhouse became available. In 1851, Charles Copeland, a wealthy Boston confectioner who lived on Spot Pond, sold the town a quarter-acre lot for $200 on Pond Street. That year, the town of Stoneham appropriated $16,000 to be used to build five schools, including the one for District Four.

Before this school was built, most children who lived along Spot Pond Brook didn't attend school at all. The nearest school was too far to reach by horseback or wagons, and the roads were in poor condition and unplowed during the winter. Also, there were no child labor laws, and domestic chores for girls and work in the mills for boys took precedence.

The District Four school was called the Wyoming School. It was a one-story, white-frame building with a granite foundation and was capped with a belfry above the entrance. The single classroom had hardwood seats, the back of one forming part of the next desk, with room for three or four on a seat. The long box woodstove was connected to the chimney by yards of slender, rusty stovepipe, which was suspended on wire loops from the ceiling. A narrow entry was hung with the outer garments of about fifty pupils.

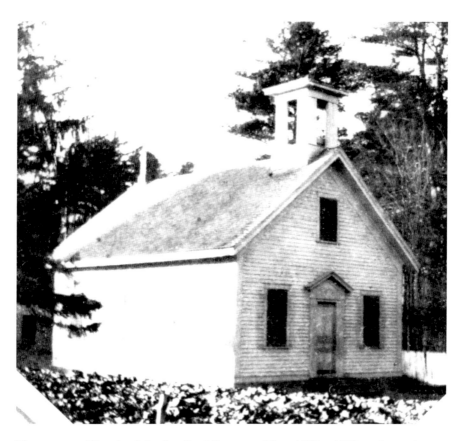

The one-room Wyoming School on Pond Street, used from 1852 to 1899 to educate the children of Haywardville. *Stoneham Historical Society.*

The school was used on Sundays for religious education. On those days, it was called the Baptist Sabbath School and was run by Daniel Jones, a Baptist pastor. The *Melrose Journal* covered events held at the Sunday school. For example, the February 14, 1874 issue reported that "the Baptist Sabbath School held a concert last Sunday evening. It was well attended, and the exercises were quite interesting." The Baptist movement at Spot Pond disbanded in the 1890s.

Unlike the other schools in Stoneham, the Wyoming School was classified as "ungraded." Grades from kindergarten to high school were taught under one roof, and students ages five to fifteen were taught by one teacher. The number of students attending the school varied. The largest number was fifty-five in 1868. After that, numbers declined to just seventeen before the school's closing in 1899.

The school calendar was similar to today, except there were fewer holidays. The fall term began in the last week of August and ended four days before Christmas. Thanksgiving was the only autumn holiday. The winter term began on January 2 and ended in mid-March, with Washington's birthday celebrated on February 22. After a two-week vacation, the spring term began in early April and ended in late June. There were two holidays during spring term: Fast Day on April 12 and Memorial Day on May 31.

In its first decade, the Wyoming School changed teachers frequently. They were all young women in their early twenties. Because of the school's remote location, working at this school probably was considered a hardship.

The first teacher at the Wyoming School was Mary Hammond, whose father was a harness maker in nearby Woburn. Wages were low. In 1852, the town of Stoneham paid her just $4 a week, or about $160 per academic year. That year, the School Committee also paid Jonathan Hay $98.55 to build a 395-foot-long fence to enclose the school yard and paid S. Wiley $9.13 to supply wood for the school's woodstove.

The following year, the 1853–54 school year, four teachers alternated teaching at the school. As well as Hammond, these teachers included L.E. Andrews, M.F. Hemenway and A.T. Brown. A local man, Elbridge Gerry, provided wood for the woodstove. The next year, all of the teachers quit, and Stoneham hired a new teacher, twenty-year-old Kate Huntress. Huntress lived with her friend, Pamelia Gould, the owner of the Gould farm (present-day Stone Zoo), and walked along Pond Street to the schoolhouse, a journey of less than ten minutes. Her salary was just $145 for the academic year.

In 1856, Huntress was replaced by R.H. Buck, who received a higher salary of $200. The town paid George Copeland, son of confectioner Charles Copeland, $17 to clean the schoolhouse and start the woodstove each morning. In 1858, Ellen Marian Whittridge, daughter of a Lynnfield shoe manufacturer, took over the teaching position. A former student, sixteen-year-old William Stafford, a brass finisher at the Grundy Foundry, and Frederick Scrannage were together paid $12.63 for their services in caring for the school that year. Whittridge had graduated from the Charlestown Female Seminary and the Newbury Seminary and Female Collegiate Institute in Vermont, giving her more training than previous Wyoming School teachers. According to Stoneham's School Committee, "The school was taught by the teacher of last year—a lady of much experience. Her success was good. She has succeeded well in introducing drawing and this school has much increased in numbers."

By this time, enrollment at the Wyoming School had increased to forty-four students, but average daily attendance was just twenty-two because some boys worked at Nathaniel Hayward's rubber factory and the Grundy foundry and some girls stayed home to help with household chores.

There continued to be a new teacher almost every year until 1862. In ten years, the salary had gone from four dollars to five dollars a week, and the school year was reduced to thirty-one weeks. Enrollment was about forty students, with twenty-two attending regularly. The Stoneham School Committee's 1861 annual report included this description:

> *Last to be enumerated is the Wyoming School, taught by Miss Edith H. Norton. The attendance in this school has been very irregular, various causes having combined to produce the inconsistency referred to. Several children who have for a portion of their time been members, have removed from the town; others have been obliged to remain at home to assist their parents in various ways; some have been detained by sickness, while in several instances some of the older scholars have availed themselves of the advantages of the Male Grammar and South Intermediate Schools. The scholars attending have evidently made a good degree of proficiency, and the teacher has labored to promote the best interests of her pupils. A considerable amount of time has been devoted to the study of geography, and singing has been one of the favorite exercises. Singing has for several years been practiced in our schools with the most satisfactory results.... Music has an attracting not a coercing power, and ever appealing to the better feelings of our nature.*

The next teacher at the Wyoming School was to have a profound impact on Haywardville's children. Born in Medford in 1841, Susan Dean was the daughter of John Dean, a Medford shoe manufacturer, and Susan W. Wade of Woburn. Her older brother, Abner, was to buy a children's shoe factory in Stoneham. When she was eight, her family moved to a house just south of John Botume's stone mansion on Spot Pond (now the Middlesex Fells Visitor Center). Susan and Abner attended the Wyoming School from the time that it opened in 1852. The school was a short quarter-mile walk from their house.

Susan completed high school in Stoneham and began teaching at the Wyoming School in April 1862. She was a hard worker, both in and out of the classroom. During her first year teaching, she replaced the school fence and cleared debris from the school yard. Edward Scrannage from the

Grundy foundry helped her with cleaning the schoolhouse and stoking the woodstove. According to the 1863 School Committee report:

This school has been taught by Miss Dean, the lady who had charge of it the preceding year. The pupils were industrious, and showed at the examination a decided advancement in their studies. We have seldom seen in this school so much enthusiasm manifested, as during the past year. It is worthy of mention that every scholar who belonged to the school the last term, was present at the examination, a fact alike creditable to teacher, scholars and parents.

Salaries continued to be low for public school teachers. At five dollars per week, Susan Dean's was typical. In 1866, the Stoneham School Committee tried unsuccessfully to get the town to raise salaries for teachers:

It is our opinion that the town could not do itself more credit or serve the purpose of education better than by raising money enough to advance the pay of those teachers who have an eye to higher salaries, and whose services are really worth about double what they now receive, so that we may retain them in their present positions. It may be possible to hire teachers for less than what we are paying, but in a town where girls can earn in our shops more than our teachers do in the schoolroom, it is not economical, it is not decent, nor is it Christian to seek to lessen the meagre sum.

As Haywardville's rubber and brass factories attracted more workers, the school filled to capacity. In 1867, as many as forty-nine pupils, ages five to fifteen, sat in the one-room classroom. The School Committee noted that Susan Dean "has labored at some disadvantage because of the large number of classes consequent upon the difference in age between the younger and older scholars, and the crowded condition of the school-room. If that portion of the town has a growth corresponding with its advantages and attractions, the day will not be far distant when an additional school-room must be provided."

The committee was also concerned that the school "was in great need of repairs; also the fence enclosing the same....[T]he roof has presented a dilapidated appearance, and has been leaking badly. The fence has pretty much disappeared; and altogether the appearance of the house and grounds does the town no merit." But the town did not provide funds, and

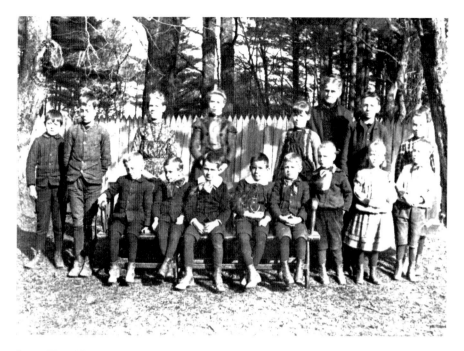

Susan (Dean) Richardson (*back row, third from right*) and her students at the Wyoming School. She taught at the school for thirty-seven years. *Stoneham Historical Society.*

conditions got worse. By 1870, the School Committee was more forceful in its plea to the town:

> *The whole building, inside and out, with its surroundings, presents a shabby appearance. The interior needs a thorough renovation. The walls are battered and soiled with age, and the blackboards are defective and insufficient. Single desks should supersede the double desks now used. The latter do not belong to this enlightened period of school appliances (although they may correspond well with the building in its present dilapidated condition). The exterior needs patching and painting, while the yard fence is in the staggering age of infirmity. Four or five hundred dollars, judiciously expended, will make this building comfortable, increase its facilities for school work, and render it also an object respectable in appearance. Complaints have been made by the parents the past winter that the building was uncomfortable in extreme cold weather.*

The School Committee, however, always praised the quality of education provided by Susan Dean. Although the committee noted in 1877 that

the school needed "a new fence, a well of water, and some improvement and renovation of the interior," it also noted that "[t]his is a good school, deserving of more praise than it receives at the hands of the public. It has been fortunate in having the same teacher for several successive years."

In December 1881, Susan married Frederick Richardson, a dairy farmer from Burlington, a town several miles away. She was thirty-nine and he was thirty-six. They decided to live with Susan's mother on Spot Pond to be near the Wyoming School. In November 1882, they had a son, Frederick. Susan only took a few months off before returning to the school the following spring. During her absence, the town hired a substitute teacher, Nellie Wilson.

Honor Students

When Frederick was five, he walked every day to school and back with his mother. Because many Haywardville children were needed at home or worked in the rubber factory (the brass foundry had closed in 1870), attendance at school was considered to be as important as academic grades. The school system maintained an "honor roll for perfect attendance," and this list was published in the School Committee's annual report. These lists show that the children of Haywardville had a diversity of backgrounds similar to many schools today. For example, Emma Caroline Atkinson was born in Haywardville in 1862. Her parents had emigrated from England, and her father, William Atkinson, worked as a brass polisher at the Grundy Brass Foundry. Emma Atkinson later became a housekeeper. The Atkinson family lived across from the Haywardville rubber factory on the other side of Pond Street.

Clarence William Goodwin, born in Stoneham in 1871, was the seventh of nine children, all of whom attended the Wyoming School. His father, Joseph Goodwin, was from Maine and worked as a "hostler" (an old English word for someone who cares for horses) for Charles Copeland, a wealthy confectioner who lived in a mansion near the Spot Pond dam. Clarence Goodwin later moved to Sanford, Maine, and worked as a fireman in a woolen mill.

Freddie Hayward, born in Stoneham in 1872, was a grandnephew of Nathaniel Hayward. Freddie lived with his parents, Charles H. and Emily Hayward, in Haywardville and went on to become a grocer like his father. His

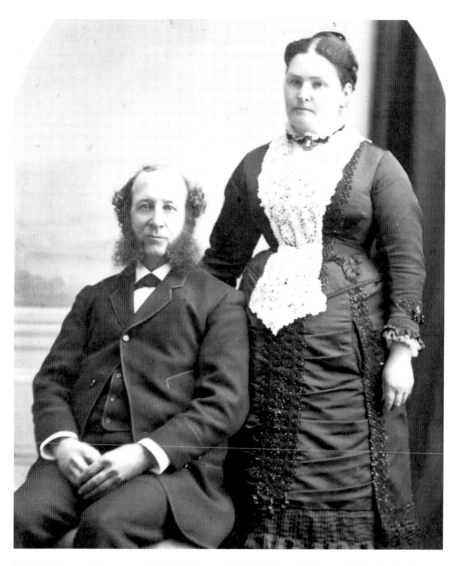

Freddie Hayward's parents, Charles Henry and Emily (Hayes) Hayward. The family lived in Haywardville, and Freddie attended the Wyoming School. *Colchester Historical Society.*

brother, Charles David Hayward, became a park foreman in the Middlesex Fells Reservation in the late 1890s.

Nellie Wing was born in Brunswick, Maine, in 1878. Her parents moved to Haywardville so her father could work at the rubber factory. After attending the Wyoming School, Wing worked as a clerk at Elisha Converse's Rubber Shoe Company in Malden.

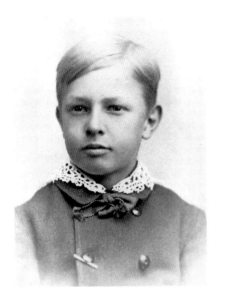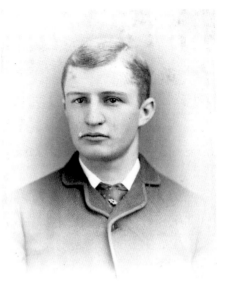

Left: Frederick "Freddie" H. Hayward, grandnephew of Nathaniel Hayward and one of Susan (Dean) Richardson's students. *Colchester Historical Society.*

Right: Charles Daniel Hayward, Freddie Hayward's older brother, who burned his hands in a fire at Haywardville in 1911. After 1894, Charles Hayward became park foreman for the Middlesex Fells Reservation. *Colchester Historical Society.*

Charles Ames also had perfect attendance at the Wyoming School. Born in 1876, he was the son of John Henry "Harry" Ames, who had fought in the Civil War, and grandson of Philander Ames, who owned a parcel of land north of Spot Pond Brook and a large farm north of Spot Pond. Ames's mother died in 1879, and he was raised by his father. They later moved to Wellfleet on Cape Cod, where the elder Ames worked as a mariner.

Grace Jones also attended the Wyoming School without missing a day. She was born about 1876 and lived in a house built around 1792 by Ebenezer Bucknam, which was located just north of the sawmill and Grundy brass foundry (both closed about 1870) in the Spot Pond Brook ravine.

Grace's older siblings, Carrie, Charles and Minnie, also attended the Wyoming School. Their father, Charles C. Jones, owned icehouses on the east side of Spot Pond and managed an ice-delivery business. While the family lived in the Bucknam house in the 1880s, Charles's wife, Mary, used the abandoned foundry building to house her chickens. In 1891, the Spot Pond Water Company took Bold Point, where the icehouses stood, and the

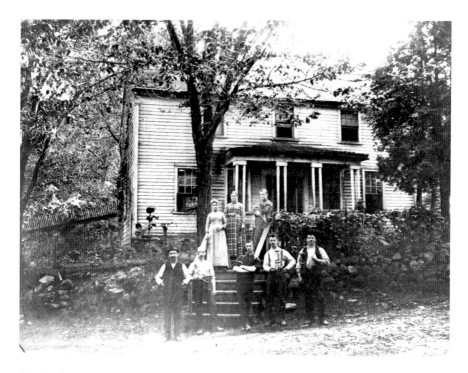

Charles Carroll Jones (*at left*) and his family in front of Ebenezer Bucknam's house in Stoneham about 1885. It was later moved to Ravine Terrace in Melrose. *Stoneham Historical Society.*

Jones family moved back to their native town of Lancaster, New Hampshire. Most of Bold Point was submerged in 1900 during reconstruction of Spot Pond into a reservoir. About 1894, the old Bucknam house was moved two thousand feet east by teams of horses to its present location on Ravine Terrace in Melrose.

Chapter 10

Demise of Haywardville, 1870s–1914

Theodore Weeks's initial success with the Haywardville rubber factory and his good credit report from R.G. Dun & Company led him to buy more properties. In August 1869, he paid Joseph Grundy $5,000 for his upstream brass foundry. Weeks ran this for a few years with the help of Grundy's sons, but it was a much reduced operation from its heydays of the 1850s and 1860s (see chapter 6). Meanwhile, his rubber factory was prospering in the late 1860s with a vibrant community of workers.

But towns around Spot Pond were looking for water supplies. At that time, each household had a private supply, usually a well, and sometimes a cistern to hold rainwater gathered from the roof. In 1867, businessmen from Medford, Malden and Melrose formed the Spot Pond Water Company to develop a public supply and built a pumping station for each city. On August 25, 1870, the towns began drawing water from Spot Pond for their municipal distribution systems, significantly reducing flow in Spot Pond Brook, especially in years of low rainfall. Malden mill owner David Dyer, the last holder of the Coytmore privilege, had effectively lost control over the flow in Spot Pond Brook. The effect of the reduced flow in Spot Pond Brook was disastrous to Haywardville. In 1935, Parker W. Perry wrote in *Round About Middlesex Fells Historical Guide-Book*:

> With most of the water from the pond diverted to the pipes of the towns, the mills faced ruin. Their owners brought suit against the separate towns, and after more than ten years of litigation all claims were finally settled.

The mills fell into decay, most of the people moved away, and the glory of Haywardville became a memory.

Only one industry remained—the ice business, as the towns had not prohibited the cutting of ice on the pond....For almost a quarter of a century there was little change in the abandoned settlement. A few families lived in the old houses, and their children played in the silent mills and went to the district school at the top of the hill. During the ice-cutting season the village regained some of its former bustle, when extra helpers lived for a time with their families in the houses that were vacant the rest of the year. Grass grew in the ruts of the old mill-roads, and the factories themselves were filled with dust and festooned with cobwebs.

After 1870, deeds show that the Haywardville Rubber Company changed hands many times. Over the next twelve years, Weeks sold the factory to one party and then bought it back and resold it to another. For example, James P. Thorndike, a Boston leather merchant, paid Weeks $10,000 for the Haywardville property and other lots in April 1871. Weeks later regained the land from Thorndike's executor. Theodore Weeks's wife, Louisa, was often the buyer and seller, and her name appears on several deeds. The large mortgages show that the company was short of capitol, while the cash flow shows that the business continued but the company probably made little, if any, profit.

By 1873, the company was in serious financial trouble. In December, the Supreme Judicial Court of Suffolk County issued an "execution" against the Haywardville Rubber Company, apparently for Weeks's failure to pay the mortgage. Two months later, the Stoneham tax collector seized Weeks's factory property because the tax bill was two weeks overdue. The collector told Weeks that if he didn't immediately pay the town $231.56, the property would be publicly auctioned.

Weeks found money to pay that bill, but two years later, in April 1875, the National Bank of North America in Boston took ownership of the factory and appointed Edward and Harrison Maynard to run it. In January 1877, the bank's board of directors authorized the sale of the company back to Theodore Weeks for $1,000.

Between October 1879 and February 1880, Weeks applied for two patents for an improved process for manufacturing vulcanized rubber boots and shoes. In 1880, he and his wife, Louisa, moved in with her cousin, Charles H. Hayward, who owned a large house in Haywardville just south of the factory. Hayward's wife, Emily, and son, Charles Daniel, also lived in the house. The 1880 federal census listed Weeks as a "Retired Rubber

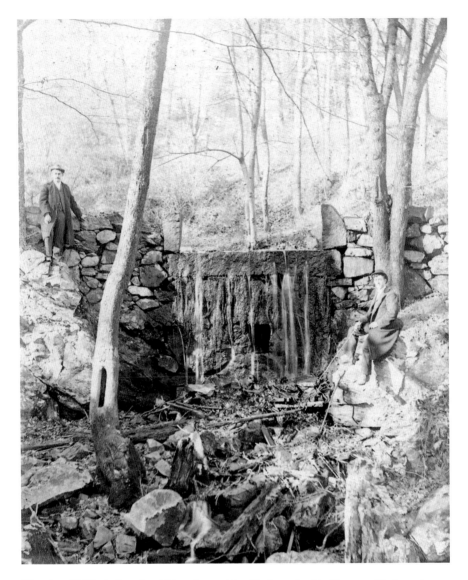

Theodore C. Weeks (*seated at right*) and an unidentified man beside Ebenezer Bucknam's dam on Spot Pond Brook in about 1880. *Stoneham Historical Society.*

Manufacturer," with an occupation as "Stock Broker." In 1881, Weeks made some bad investments for the Pacific National Bank of Boston, and the bank failed when it was unable repay a debt of $1.25 million.

In May 1882, Theodore and Louisa Weeks sold the 2.8-acre rubber factory for $6,500 to Louisa's brother, William Hayward, who lived in Colchester,

Theodore C. Weeks and his driver, "Mack," in about 1890. *Colchester Historical Society.*

Connecticut. A few months later, Hayward sold the factory property to William V. Higgins of Malden for $7,000. In November 1883, Higgins sold it to Charles F. Donnelly of Boston for "One Dollar & other valuable considerations." The sale included "all the machinery, engines, boilers, apparatus, implements & fixtures & other personal property whatsoever… within the buildings thereon situated." Finally, in 1886, Donnelly sold the property back to Louisa Weeks for $10,000. This price shows that the factory was still considered a profitable enterprise.

In 1891, Medford, Malden and Melrose bought the land bordering Spot Pond as an antipollution measure. A few years later, the inevitable happened: Boston looked again at Spot Pond when Lake Cochituate failed to meet the growing city's water demand. In January 1898, control of Spot Pond passed to the Boston Metropolitan Water Board (MWB), which hired Olmsted Brothers landscape architects to develop plans to enlarge Spot Pond as a reservoir as part of Boston's northern distribution system while retaining its natural beauty.

In late 1898, to prevent pollution from entering Spot Pond, the MWB cut off all flow from Spot Pond into Spot Pond Brook and diverted flow from more than seven hundred acres north of Spot Pond, including Dark Hollow and Doleful Ponds, into Spot Pond Brook. Without its source water from Spot Pond, Spot Pond Brook became a much smaller stream, one that can hardly be imagined as capable of powering a community of mills.

Wyoming School's Final Years

After the Haywardville rubber factory closed in 1893 or 1894, the number of children at the Wyoming School declined rapidly as families left Haywardville. The Stoneham School Committee considered the school's future:

> *The perplexing question of discontinuing the Wyoming School must soon be met. At present the school has but eight members; there will probably be two in addition to these at the opening of the spring term....The small number of children in the North street and Wyoming schools seems to indicate that the time has come seriously to discuss the question suggested in the last Annual School report, whether it will not be for the best interests of all concerned to discontinue these schools.*

In 1896, the committee conceded that the small number of students attending the school "is likely to be permanent as nearly all the land in the vicinity of the school-house is now included in the Metropolitan Park and it is said that only two or three houses on this land will be allowed to remain." However, it kept the school open until 1899 because the nearest schoolhouse was being used by Melrose as a high school until its new high school was built, and other schools were considered too far a walk for the thirteen remaining Wyoming School children.

The brass bell used by Susan (Dean) Richardson at the Wyoming School. *Photograph by Jim and Priscilla Scroggins, Richardson's great-granddaughter.*

The school finally closed on April 14, 1899, and Susan (Dean) Richardson retired after nearly four decades of teaching, the longest-serving teacher in Stoneham. She was still living with her widowed mother, husband and son in a house beside Spot Pond, even though the land and house now belonged to the state. Her father, John, died in 1879. In 1891, the Towns of Malden, Melrose and Medford had paid Susan's mother $4,000 for her property when they began using Spot Pond for a water supply. However, the towns had allowed Susan's family to continue living there as long as she taught at the Wyoming School. In the

The gold pocket watch owned by Susan (Dean) Richardson. *Photograph by Donald Delay, Richardson's great-grandson.*

summer of 1899, they moved to Frederick Richardson's dairy farm in the nearby town of Burlington.

The Wyoming School was razed in early 1900 by Italian immigrants as part of the state project, carried out by Olmsted Brothers landscape architects, to transform Spot Pond into a reservoir for Boston. In July 1911, after a nine-month illness, Susan (Dean) Richardson died of cancer at age seventy at her home in Burlington, leaving behind her husband and son. Only two of her possessions are known to have survived: the brass bell she rang to call children to class and a gold pocket watch.

State Takeover

In the early 1890s, local developers proposed transforming the Haywardville area into a residential area by selling house lots. They went so far as to lay out several new streets on paper. These plans were abandoned when the state decided to buy Spot Pond as a reservoir for Boston along with all the surrounding land. In February 1894, the Metropolitan Park Commission (MPC) took all of this land for the new Middlesex Fells Reservation by eminent domain and distributed more than $500,000 to the landowners.

In July 1894, Theodore and Louisa Weeks signed a Memorandum of Agreement with the MPC, transferring six acres of land in two lots (nos. 1 and 2 on page 108) to the commission for $8,000. The Hayward family—including Theodore and Louisa Weeks; Emily Hayward, the widow of Charles H. Hayward; and her son, Charles Daniel Hayward—were allowed to live in the house on lot no. 1 for the rest of their lives.

On the same day, the Weeks family sold another six acres (lots nos. 3 and 5) for $10,000 to the MPC. These lots comprised the main part of

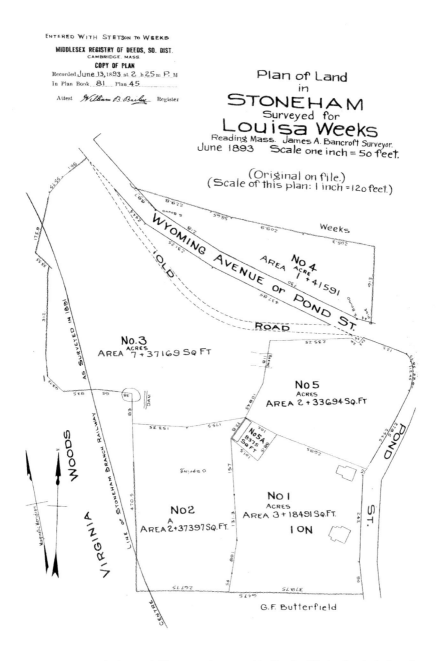

A June 1893 plan of Haywardville properties owned by Louisa Weeks shortly before the land was taken by Massachusetts as part of the Middlesex Fells Reservation. *South Middlesex County Registry of Deeds.*

Haywardville. Lot no. 3 included the old Bucknam sawmill and Grundy brass foundry, and lot no. 5 included the Haywardville rubber factory.

In 1894 and 1895, photographer Nathaniel Stebbins, working for the Olmsted Brothers firm, took photographs of the abandoned mills. Two other photographs taken about 1880 by an unknown photographer were included in a Hayward family album given to the Colchester Historical Society in Connecticut.

On April 25, 1896, the Haywardville factory buildings were auctioned by the state for removal or demolition. The revenue from this auction totaled only $393. Over the next thirty days, the buildings and the 130-foot-high brick chimney were razed, and the materials and machinery were removed by the winning bidders. As reported in the May 2, 1896 issue of the *Melrose Reporter*:

> *The old red mills, near the Stoneham line, which were formerly occupied for the manufacture of rubber goods, were sold at auction last Saturday by the metropolitan park commissioners. The buildings are located on the*

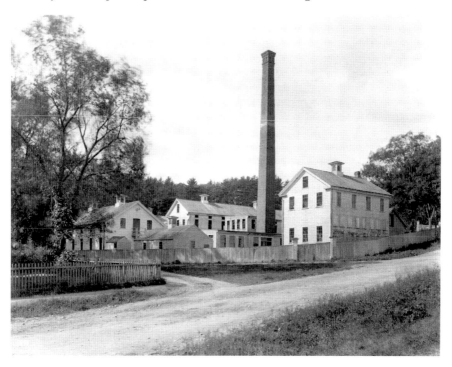

Haywardville looking southwest, as photographed by Nathaniel Stebbins in October 1895. *Massachusetts Archives.*

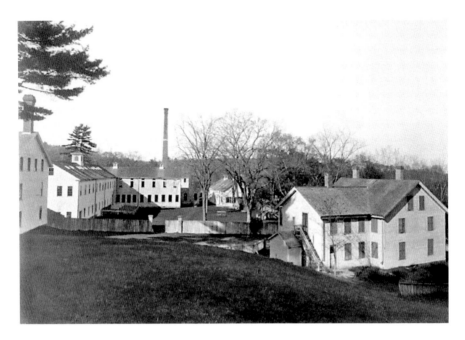

Haywardville looking northeast, as photographed by Nathaniel Stebbins in May 1894. *Massachusetts Archives.*

boulevard, and before the sale it was stated that they would have to be removed at once. It is said that the buildings cost nearly $100,000 to construct, and they were sold at auction for $393. The buildings have been in a dilapidated condition for years.

Parker Perry, who drew a map of Haywardville in 1860 (see page 15), described the fate of all the buildings in Haywardville in *Round About Middlesex Fells*, published in 1935:

The Red Mills buildings in Haywardville were cut into sections, transformed into houses, and moved a half-mile east to form a street called, until recently, Fells Court. (It has lately blossomed out with the pretentious title of Ravine Terrace!) Most of the other buildings, including the tenement, the spice and brass mills, the old Kendall House, the schoolhouse and the general store, were razed, but the Bucknam House, the "haunted house" and one other were moved down Wyoming Avenue, where they stand today, although in a much altered state.

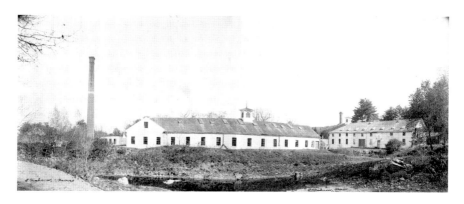

Haywardville in about 1880 looking south from the millpond. Unknown photographer. *Colchester Historical Society.*

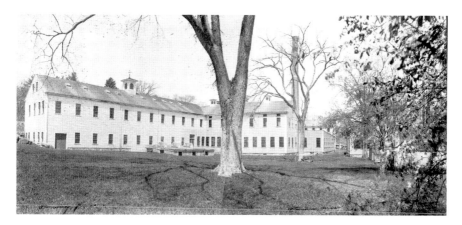

Haywardville in about 1880 looking north. Unknown photographer. *Colchester Historical Society.*

The Park officials smoothed over the scars where the buildings had stood, and allowed grass and bushes to grow naturally over the old foundations and cellar holes. The only additions were a charming rustic bridge over the falls above the gorge, and a fence around the lower millrace. In the thirty-odd years since the state bought the land in 1896, the site of Haywardville had become one of the loveliest rustic retreats north of Boston, until its recent conversion into a nature trail robbed it of its more primitive charm.

Haywardville is still well worth a visit by all who cherish the few remaining vestiges of an era in our history now closed. With a little study and imagination the visitor can easily reconstruct the thriving village of a century ago.

An April 1896 notice of the auction held by the Metropolitan Park Commission to sell Haywardville buildings and equipment. *From the* Melrose Reporter, *in the Melrose Public Library microfilm collection.*

The Hayward family continued to live in the large white house just south of where the rubber factory once stood. According to the 1900 federal census, family members included Charles Daniel Hayward (Nathaniel Hayward's great-nephew); his mother, Emily Hayward; and Theodore Weeks and his wife, Louisa (Hayward) Weeks. After 1894, Charles D. Hayward became a park foreman for the new Middlesex Fells Reservation. Emily Hayward died in 1902, and Theodore Weeks died from kidney disease in 1905. His obituary in the *Melrose Free Press* noted:

Weeks came to Melrose about 40 years ago, and was interested in the Hayward Rubber Mills, which were then doing a flourishing business in that locality. Of late years he has been a stock and mining broker in Boston. He resided in the old mansion house, now in the Middlesex Fells Reservation, and was well known to many of our Melrose citizens.

On August 13, 1911, the Haywards' house was badly gutted by fire. As reported by the *Stoneham Independent*:

The alarm from box 37 Sunday morning at 11.05 o'clock was for a fire in the old Weeks place, in the Middlesex Fells Reservation, near the Melrose-Stoneham line. Chief Bruce was notified of the fire by telephone and rang in the alarm from the fire station. The Melrose fire department also responded, but were unable to get an effective stream on the blaze owing to the poor pressure. This was remedied on the arrival of the local department, with [the] Col. Gould steamer. The flames had attained considerable headway before the local firemen could cover the long run to the scene, but were speedily checked although not until the building was damaged to the extent of $2,000 or more. The house, which is a large one, is occupied by Mrs. Louisa Weeks and Charles D. Hayward and family. It is the only house in the Middlesex Fells Reservation not owned by the state. The property

is owned by Mrs. Weeks with the agreement that at her death it shall pass into the hands of the state. The house is located at the site of the old Red Mills, in which rubber goods were extensively manufactured many years ago. The fire originated in a peculiar manner. Mr. Hayward had taken a lighted lantern into the cellar for the purpose of locating some polish which had been stored there. The polish came in contact with the flame of the lantern when it spilled, having been tipped over, and an explosion resulted. Mr. Hayward was slightly burned about the hands while attempting to extinguish the flames, which spread rapidly up through the roof in the Hayward apartments, and that side of the house was badly gutted. All out was sounded at 1.15 p.m.

Local newspaper accounts, like the one above, often referred to the Stoneham rubber factory as "the old Red Mills." However, no existing documents use this name for the Stoneham mill buildings. The name "Red Mill" is only mentioned in documents that refer to one of William Barrett's dye house buildings in Malden. These include an 1828 inventory of Barrett's dye works (see page 77), Barrett's estate inventory of December 1834 and two indenture contracts (or lease agreements) with men named Daniel Perkins and Benjamin Johnson, dated March 1837 and January 1841, respectively. This "Red Mill," which was mainly used to grind grain, was located on six acres south of the Medford Road in Malden. It remains a mystery how the white-frame factory buildings in Stoneham became known as "the old Red Mills."

Louisa Weeks died in 1913. In accord with the 1894 agreement, her house and land were transferred to the state. In September 1914, the Metropolitan Park Commission razed her house, removing the last of Haywardville's buildings. After 274 years of settlement, the mill community along Spot Pond Brook ceased to exist.

Chapter 11

Virginia Wood, 1891–Present

In 1846, Joseph Hurd sold 120 acres of property along Spot Pond's eastern shore to Boston businessmen William Foster Jr. and Thomas Eaton. This property bordered the west side of Haywardville (land west of Lots 2 and 3, on page 108). These two, in partnership with William Bailey Lang, an iron and steel merchant as well as architect, developed the land into an area that they called "Wyoming Estates." They auctioned off lakeside lots but kept some for themselves, on which they built Italianate mansions designed by Lang and built with granite from quarries to the west of Spot Pond. In 1862, a year before he died, Foster gave one of his lots that included one of the Italianate mansions to his daughter, Fanny. Taken by the beauty of the Spot Pond Brook ravine, William Foster wrote in 1862:

> *A few days ago the Bunker Hill paper published an article of the rare beauty of a water-fall at Wyoming or Spot Pond—sometimes dry, when the miller chooses to shut down the gate. This Fall among the high forest trees and over the craggy rocks is really worthy of notice. It is not mine but the brook which is the only issue from Lake Wyoming* [Spot Pond] *runs through my forest of very lofty trees, nearly a hundred feet high.*

Until 1862, Fanny Foster lived with her father in his large Boston mansion on Summer Street. Her mother, Marie, died in 1838. William Foster became wealthy from fees that he collected from merchants for the privilege of using his wharves, which he had inherited from his parents.

As well as being a businessman, Foster was a well-known politician who associated with people such as John Quincy Adams, Martin Van Buren and Daniel Webster.

In 1844, Fanny Foster married Henry James Tudor, twenty-two years her senior and the younger brother of "Ice King" Frederic Tudor, who created the first natural ice business in the United States. From 1826 to 1892, the Tudor Ice Company employed local men and boys to cut ("harvest") ice from ponds in eastern Massachusetts, including Spot Pond and nearby Doleful Pond. The ice was stored in icehouses on the shores of the ponds and transported by rail to Boston for use at breweries, hotels and packinghouses and for shipment overseas to England, the Caribbean and as far as India. Before his marriage to Fanny Foster, Henry Tudor worked as a field agent for his brother's ice business.

Henry and Fanny Tudor continued to live with William Foster and, by 1850, had three daughters: Fanny, Emma and Virginia (Ginnie). However, only Ginnie reached adulthood. She was twelve in 1862 when William Foster gave her mother, Fanny, the Italianate mansion beside Spot Pond. Ginnie was already familiar with the area from visits to her grandfather's "Wyoming Estates" and expressed a love for nature and running in the woods near Haywardville. The Tudors—Fanny, Henry

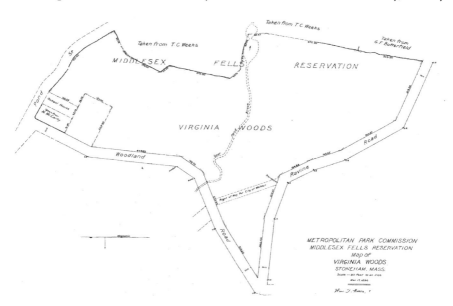

A March 1896 plan of Virginia Wood by the Metropolitan Park Commission. *Middlesex South Registry of Deeds.*

Left: David E. James of Boston made this 1856 ambrotype of Virginia Tudor, to whom Virginia Wood is dedicated. This is the only known photo of Tudor. *New England Historical Genealogical Society*.

Below: Fannie (Foster) Tudor and her daughter Virginia (Ginnie) lived in this Italianate mansion beside Spot Pond from 1862 to 1867 before moving to France. It was designed by architect William Bailey Lang and built by Richard Christian of Boston about 1848. *New England Historical Genealogical Society*.

Charles Eliot, founder of the Trustees of Public Reservations, designed this bronze plaque in 1896. It was cast by the Murdoch Parlor Grate Company of Boston and mounted in Virginia Wood in about 1900. *Massachusetts Archives.*

and Ginnie—soon moved into the stone mansion on Spot Pond. Rather than sending their daughter to the nearby Wyoming School, which did not meet their upper-class standards, Fanny hired a governess.

They had been in the mansion for only two years when Henry Tudor died in 1864. Fanny had lost her father, William Foster, the year before. Not wishing to live alone with her daughter in the large house, Fanny took Ginnie to France to visit Fanny's widowed sister, Virginia Coppinger. French culture and life suited them, and they decided to stay. Ginnie Tudor died in Paris of unknown causes in 1886 and was buried in the family plot at Cambridge's Mount Auburn Cemetery. In 1891, in memory of her daughter, Fanny offered a twenty-acre parcel near Haywardville to the newly formed Trustees of Public Reservations, the first private conservation land trust in the world. She asked the organization to call the property Virginia Wood.

The Trustees delayed accepting the offer until they had raised $2,000 to manage the property. Members of the Appalachian Mountain Club also contributed funds. In February 1892, the Trustees, headed by famous landscape architect Charles Eliot, accepted the offer. Unfortunately, Fanny died in Paris that April before receiving word about her bequest. She was buried next to her daughter at Mount Auburn Cemetery. Four years later, Eliot designed a bronze plaque for Virginia Wood, which was set into a bedrock outcrop near its entrance on Pond Street. In 1923, the Trustees donated Virginia Wood to the state, which incorporated it into the Middlesex Fells Reservation. In July 1992, the Metropolitan District Commission (now the Massachusetts Department of Conservation and Recreation (DCR)), established the Spot Pond Archaeological District, which includes both Virginia Wood and Haywardville. The Friends of the Middlesex Fells Reservation, a private organization formed in 1989

and based in Melrose, is dedicated to educating the public about this remarkable area. In the early 1990s, the Friends of the Fells and the DCR developed a marked trail along Spot Pond Brook describing the history of the mill community of Haywardville.

While no Haywardville residents or millworkers are alive today, a trove of documents records their stories, from court cases to school rosters. The land within Middlesex Fells preserves remnants of a community long gone. It is still possible to stand on the bridge crossing Spot Pond Brook, look down on the waterfall plunging into the ravine and imagine the sound of waterwheels and machinery grinding and pounding their way into a future that the people of Haywardville could not have imagined but that we have inherited.

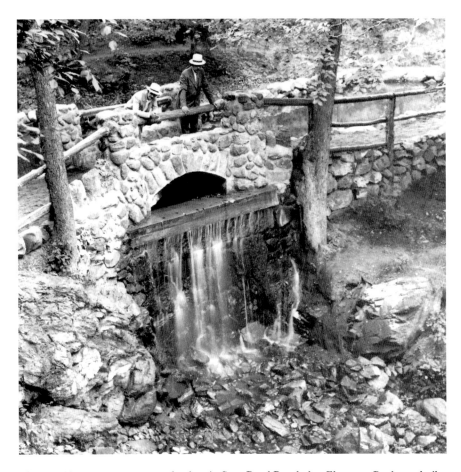

About 1940, two men peer over the dam in Spot Pond Brook that Ebenezer Bucknam built in 1792. *Massachusetts Archives.*

Bibliography

Barrett, Artemus. "Timothy Sprague and Spot Pond: Interesting Scraps of History." *Melrose Journal*, January 31, 1885.

Bishop, J. Leander. *A History of American Manufacturers from 1608 to 1860*. Philadelphia: Edward Young & Company, 1868.

Brown, Jonathan. *Water Power and Watermills*. Ramsbury, Wiltshire, UK: Crowood Press, 2011.

Chamberlain, George Walter. *The Spragues of Malden*. Boston: private printing, 1923.

City of Boston. *Third Report of the Record Commissioners Containing Charlestown Land Records, 1638–1802*. Boston: Rockwell and Churchill, City Printers, 1878.

Commonwealth of Massachusetts. *Cities of Malden, Medford and Melrose v. Commonwealth of Massachusetts at Superior Court*. Boston: Wright & Potter, 1904. (All quotations from court documents in book are from this source.)

Corey, Deloraine Pendre. *History of Malden, Massachusetts, 1633–1785*. Malden, MA: self-published, 1899.

Cressy, David. *Coming Over: Migration and Communication between England and New England in the Seventeenth Century*. Cambridge, UK: Cambridge University Press, 1987.

Dean, Silas. *A Brief History of the Town of Stoneham, Mass. From Its First Settlement to the Year 1843*. Stoneham, MA: Sentinel Press, H.C. Gray, Printer, 1870.

Dow, George Francis. *Everyday Life in the Massachusetts Bay Colony*. New York: Arno Press, 1977. Also at http://www.gutenberg.org/files/43970/43970-h/43970-h.htm.

Evans, Oliver. *The Young Mill-Wright and Miller's Guide.* Philadelphia: self-published, 1795.

Forbes, Abner. *The Rich Men of Massachusetts.* Boston: Redding and Company, 1852.

Frothingham, Richard, Jr. *The History of Charlestown, Massachusetts.* Boston: Charles C. Little and James Brown, 1845.

Goss, Elbridge H. *History of Melrose, County of Middlesex, Massachusetts.* Melrose, MA: self-published, 1902.

Hamilton, Edward Pierce. *The New England Village Mill. Old-Time New England.* Vol. 42, no. 2, serial no. 146. Boston: Society for the Preservation of New England Antiquities, October–December 1951.

Higginson, Francis. *New-Englands Plantation.* London: printed by T.C. and R.C. for Michael Sparke, 1630.

Hildebrand, Daniel. "An Historical Survey of the Mill Lots in Virginia Wood." Unpublished manuscript, EIP Intern, Middlesex Fells Reservation, Boston, MA, June–August 1988.

Hunter, Louis C.A. *History of Industrial Power in the United States, 1780–1930.* Charlottesville: University Press of Virginia, 1979.

Hurd, Charles Edwin. *Representative Citizens of the Commonwealth of Massachusetts.* Boston: New England Historical Publishing Company, 1902.

Larkin, David. *Mill: The History and Future of Naturally Powered Buildings.* New York: Universe Publishing, a Division of Rizzoli International Publications Inc., 2000.

Laskey, Frederick A. *A History of Boston's Water System*, 2014. http://www.mwra.com/04water/pdf/040314-water-history-umass.pdf.

Malden Historical Society. *Proceedings of the Two Hundred Seventy-Fifth Anniversary of Malden, Massachusetts: Malden Auditorium, May 25, 1924.* Malden, MA: Malden Historical Society, 1990.

———. *The Register of the Malden Historical Society, Malden, Massachusetts*, no. 1 (1910–11) and no. 2 (1911–12). Lynn, MA: Frank S. Whitten, Printer, 1910 and 1912.

Mann, Charles E. "The Governor's Lady." *The Register of the Malden Historical Society*, no. 6 (1919–20): 13–30. Lynn, MA: Frank S. Whitten, Printer, 1920.

Massachusetts Superior Court. *City of Malden, et al., Petitioners, v. Commonwealth, May 1905.* Boston: George H. Ellis, Printers, 1905.

Medford Historical Society. *Round About Middlesex Fells Historical Guide-Book.* Medford, MA: Medford Historical Society, 1935.

Metropolitan Water Works Museum Inc. "The History of Bringing Water to Boston," 2016. http://waterworksmuseum.org/history-and-stories/social-history/water-system-history-all-pages.

Middlesex County Probate Court Records. Selected probate records from 1715 to 1913, Cambridge, MA.

Middlesex South Registry of Deeds. Selected deeds from 1707 to 1894, Cambridge, MA.

Pagano, Anthony. *Melrose*. Dover, NH: Arcadia Publishing, 1998.

Porter-Phelps-Huntington Papers. Amherst College Archives and Special Collections, Amherst, MA.

Simcox, Alison C., and Douglas L. Heath. *Middlesex Fells*. Charleston, SC: Arcadia Publishing, 2015.

Simon, Rebecca. "Pirate Executions in Early Modern London." English Legal History, July 9, 2014. https://englishlegalhistory.wordpress.com/tag/high-court-of-admiralty.

Standish, Lemuel. *Stoneham, Massachusetts: The Friendly Town*. Salem, MA: Deschamps Bros., Printers, 1937.

Stevens, William B. *History of Stoneham with Biographical Sketches*. Stoneham, MA: F.L. and W.E. Whittier, 1891.

Thorsen, Linda. "The Merchants' Manufacturer: The Barrett Family's Dyeing Business in Massachusetts and New York, 1790–1850." Master's thesis, Harvard University Extension, Cambridge, MA, 2015.

Tinniswood, Adrian. *The Rainborowes: One Family's Quest to Build a New England*. New York: Basic Books, 2013.

Town of Malden, Massachusetts. *Memorial of the Celebration of the Two Hundred and Fiftieth Anniversary of the Incorporation of the Town of Malden, Massachusetts, May 1899*. Cambridge, MA: University Press, 1900.

Town of Stoneham, Massachusetts. *Annual Reports 1852 to 1899*. Stoneham, MA: Stoneham Public Library, 2016.

Index

About the Authors

Douglas Heath was born in New Jersey and grew up in Taos, New Mexico, and New York City. He worked as a hydrogeologist at the U.S. Geological Survey and U.S. Environmental Protection Agency for thirty years, where he specialized in protecting drinking water supplies in New England. As well as his work as a scientist, he is an experienced genealogist, local historian and photographer in using nineteenth-century glass plate methods.

Alison Simcox was born in Chelmsford, England, and grew up in Lexington, Massachusetts. In 1998, she was the second woman to earn a doctorate in engineering from Tufts University. She currently works at the U.S. Environmental Protection Agency as a specialist in particle pollution and biomass energy. In her free time, she enjoys playing soccer, bicycling, running and ocean kayaking.

In addition to this latest book on one of America's earliest mill communities, Doug and Alison are authors of three books in Arcadia Publishing's Images of America series: *Lake Quannapowitt, Breakheart Reservation* and *Middlesex Fells.*